THE ULTIMATE
DRAM
POT

COLLECTION

100
MONOLOGUES
FOR YOUNG
PERFORMERS
BY JOANNE WATKINSON

Salamander Street

First published in 2020 by Salamander Street Ltd.
(info@salamanderstreet.com)

The Ultimate Drama Pot Collection © Joanne Watkinson, 2020

10 9 8 7 6 5 4 3 2 1

For Abbi & Evan

Joanne Watkinson is a forty-six-year-old writer from Yorkshire. She started writing when she was a teenager, and continued to do so through to adulthood, although it took nearly two decades before she allowed anyone to read anything she'd written. In the early nineties Joanne studied Performing Arts in Cheltenham, Gloucestershire gaining a BA Hons, and went on to study for a PGCE in Drama and English at Bretton Hall college. In 1996 she took up a Drama and English teaching post at a school in South Yorkshire where she stayed for nineteen years heading up a successful performing arts department. Alongside her teaching commitments she examined for GCSE and A-Level practical exams travelling around the country. But after a devastating set back due to a serious illness, made the difficult decision to leave her teaching career to fulfil a dream of opening her own theatre school and becoming a writer. Elite Theatre Arts opened in Doncaster nearly five years ago and continues to go from strength to strength. Last year Joanne set herself a new challenge and started up ETA Management, a casting agency for children and young adults, she continued writing along side setting up the businesses and after several successful years of self publishing her monologues were picked up by LAMDA for their recent Anthology. Working with children has always been an important part of Joanne's career and to date she has directed over fifty plays and shows across Yorkshire including some of her own material, which she continues to enjoy writing. Joanne is so pleased to have joined forces with Salamander Street, and is looking forward to new goals and opportunities.

Be Inspired...

"Acting is magical. Change your look
and your attitude, and you can be anyone."
Alicia Witt

"Acting is the ability to dream on cue."
Ralph Richardson

"Acting is not about being famous,
it's about exploring the human soul."
Annette Bening

"We must all do theatre, to find out who we are,
and to discover who we could become."
Augusto Boal

"All our dreams can come true
if we have the courage to pursue them."
Walt Disney

Contents

SUITABILITY: PRE-TEEN

SUITABILITY: PRE-TEEN/YOUNG TEEN

SUITABILITY: TEEN

SUITABILITY: TEEN/YOUNG ADULT

SUITABILITY: YOUNG ADULT

Monologue Activities

- Once you have selected a suitable monologue it's time to start learning the lines, I suggest that splitting it up into small paragraphs is the best way to do it, but everyone is different. Another good way is to record the lines onto a device and play back regularly until the lines sink in.

- There are many drama elements to consider when preparing a monologue for performance.
 1. Pace, pitch and pause.
 2. Intonation
 3. Positioning
 4. Physicality (body language, facial expression, posture, gesture)
 5. Where the other characters are on the stage, in other words where should the actor's focus be?
 6. Set, e.g. if is a chair needed.
 7. Props, e.g. are small hand props required?

- Make sure you understand the character, you could create a role by pinning notes onto the wall to help develop your role. For younger performers it can help to draw a picture of the character. Consider what they are wearing, what objects are in the picture? What do they mean/or tell us about the character?

- Hot seating is another good activity to help you think more deeply about the character. This is where your peers ask you questions about your character and you would answer in role.

- Develop improvisations playing the character from your monologue.

- What has happened before and after this moment? Write a paragraph to put the piece in context. You could also

improvise a scene leading up to the monologue or after it.

- How is your character feeling? Does this change during the monologue? You could colour code the dialogue. For example, yellow for happy, red for angry, green for jealous, etc.

- Who else is in the scene? In other words, who is your character talking to? Is it the audience or are there other characters that the audience needs to imagine on stage? A good example of this is the monologue 'Fleeced', as the character Bo Peep talks to a number of characters along the way. You would need to decide exactly where on the stage each one is. For example, if Humpty is up stage left on his wall, then Bo Peep's eyeline would need to be high; if she moves downstage to address Mr Cow then her eyeline would need to be lowered.

- Task - Annotate the script with moments of pause / or elongated pause//. Don't be afraid to pause, silence can be as effective as speech. Experiment with adding or taking away the pauses to get the balance right.

Rehearsal Tasks

- Physicalise the monologue, in other words mime it. Perform it using facial expression, body language, gesture and posture. Or ask a friend to read it while you focus on physicalising the scene.

- Focus on expression, highlight words that you feel need emphasising and experiment with the delivery.

- If working in a class, whisper your monologue until your teacher calls your name, then bring it to life for stage from wherever you are up to in the dialogue; once another person's name is called, return to a whisper.

- Experiment with dynamics. On a scale of 1 to 10: 1 is very understated, 5 very natural, 10 extremely exaggerated. Which number is right for your piece? Does it change? For example, it could start quite understated at 4, then the character could get angry and the piece reaches an 8 at its climax.

- How is tension created? Through pause, breathing, physicality. You could draw a tension graph to demonstrate the levels of tension. Is the climax in the middle? At the end? Maybe there isn't an obvious climax.

- If you are talking to an imaginary character, you could write a duologue between the two to help further your understanding of their relationship. An example of this is 'Cowboy Trumps Indian' or 'Pirate Not Princes', where the characters are speaking to one other person.

- Pace is really important. Delivering your monologue with long pauses can work well for emotional pieces. For example, in 'My World' where the character is upset about losing a pet, or 'When the World Turned Grey' about the Hillsborough disaster. Try to avoid taking a breath/pausing

at every punctuation mark; sometimes a breath/pause mid-sentence can aid the tension or emotion. Spend time experimenting with this to avoid over-using rhythm in a monologue, which can affect the realism.

- Use the monologue 'Bitter Sweet Nightmares' to work on elongated moments of silence and mime. Take the section where the character Oliver is watching and reacting to a horror film. Facial expressions are important here. Using a mirror is a useful tool to find the most effective and realistic expressions to demonstrate his increasing level of fear.

- Never dive straight into a monologue after you've introduced it. Take time to set the scene with movement or even stillness. Always take a pause after the closing line before coming out of character. Miming can be a useful tool as a lead into the monologue. Read the monologue 'Up High' and come up with some movement that will demonstrate the fact that the character is on a rollercoaster, which will appropriately set the scene. This piece would benefit from movement at the end too.

- Try your monologue in many different ways to find what works best. For example, try 'I Won't Choose' or 'When the World Turned Grey' using an angry emotion, then try it with sad emotion throughout. Finally try a mixture or the two emotions. Which works best? Does it evoke empathy from the audience? You could film the two versions to compare.

- Understanding the space you are performing in is important. Know your stage.

UP STAGE RIGHT	UP STAGE CENTRE	UP STAGE LEFT
CENTRE STAGE RIGHT	CENTRE STAGE	CENTRE STAGE LEFT
DOWN STAGE RIGHT	DOWN STAGE CENTRE	DOWN STAGE LEFT

- Use the monologue 'Curtain Going Up!' which refers to specific stage directions in the text, to practise blocking a performance.

- Try your monologue sat down on a chair, on the floor, stood up or a mixture to find out which one is most effective. Remaining still at centre stage can sometimes be as effective as moving into different areas. Would a simple staging block work? For example, in 'Geronimo', it can be used to create an illusion of height.

The most important thing about performing a monologue is that it's an enjoyable experience. If you enjoy performing it the chances are the audience will enjoy watching it.

FEISTY FAIRY
Suitability: Pre-teen
Character: Elfina

Elfina lives in the forest with other fairies, but their home is being threatened as a digger prepares to tear down the trees.

What's that noise? Is it an earthquake? The end of life as us fairies know it? Oh no the noise, the noise! It hurts my ears. Where should I hide? What about under here? Hmm don't think this pile of leaves will save me. What was that? I felt the ground shake, this is scary. The forest is my home; I don't want to leave, but I don't want to die either. Timber? Did you hear that? A voice calling 'Timber', who is Timber? And whoa! Who is that giant with a big metal arm and chattering teeth? Now I'm really scared, the Giants are taking over, destroying our homes, stamping through our forest. Right! That's it, come on Elfina, you can do this. Oi you, ugly features, I'm talking to you. What do you think you're doing with your growling arm? Are you trying to steal our trees? Well you can't have them, we live in the trunks, you are a thief! You will never get your full set of wings with that attitude. Hey big guy, I'm talking to you. I'm down here! Yes, that's right, I'm not going to let you scare me anymore!

JACK
Suitability: Pre-teen
Character: Annie

Annie tries to come to terms with losing her first pet.

I'm sorry I wasn't there for you when you needed me most. Momma said you went quietly and wouldn't have felt anything, that's something. I brought you your favourite, it's a bone, and I've just put this pretty ribbon around it. I had this ribbon in my hair when momma sat me down. "Honey," she said. "I have something very difficult to tell you." She didn't need to tell me though because I just knew. That day when the school bus pulled up and I jumped down onto the pavement you didn't run to me, there was silence and I knew. I knew that no barking, and no friendly face to meet me from the bus meant there was something wrong. "It's okay Momma," I said. "You don't have to say it out loud, I already know," and a single tear trickled down her face. I didn't cry, I just sat there being brave for Momma, but to be honest right now sat here talking to you I don't feel quite so brave. Momma said it's okay to cry, that sometimes it's important and can make things better. Oh Jack, I'm so sorry I wasn't there that day, please forgive me. I will never get another pet. Momma said I can have whatever I want, but I won't, I won't replace you. You were my best friend and you will live here in my heart forever. I love you Jack.

MY FRIEND HENRY
Suitability: Pre-teen
Character: Lily (Sock puppet required)

Lily tries to reassure her sock puppet Henry that his brother who has gone missing is probably just on holiday.

My mum said, "It's just a sock Lily." Just a sock? How many socks have you seen with eyes? Look at Henry's big gorgeous black eyes, so I said to Mum, "How many socks do you know that can see just like you and me?" She sighed and went to make tea.

Henry is my best friend, he used to have a twin brother called Shamus but he's been missing for a few weeks now. He says I make him feel like a pair again. "I'm sure Shamus has just gone on a nice holiday," I said to Henry reassuringly, but I'm not sure I believed that myself. Shamus was the quiet one and he was very clumsy. Like Henry, he tried to avoid dangerous situations, the washing machine for instance, but he wasn't as streetwise as Henry and between you and me I fear the worst. Ssh! Keep that to yourself, here comes Henry now. Hi Henry, you look smart today. *(He whispers in Lily's ear.)* Oh, wow that's great can I come to the party too? *(Whisper)* What do you mean it's just for people like you? *(Whisper)* That is not true Henry, you're just like me, you're beginning to sound like my mum. *(Whisper)* You're missing Shamus? I know you are it must be tough, but I can be your other half, we can

be a pair. *(Whisper)* Why not? I know we aren't identical looking, but we have the same sense of humour. What do you call an Alligator wearing a vest? An investigator. Why aren't you laughing? Are you really so sad without Shamus? Well can't you at least try to have fun? I'm your friend too, and it's rude not to laugh at someone's jokes. Well if you're going to be like that and stay miserable just because Shamus has taken a little vacation then I think it's time you went on a trip too! *(Pulling the sock from her hand.)* Mum! I've got some dirty washing!

PETER PAN IN WONDERLAND
Suitability: Pre-teen
Character: Peter Pan

Peter finds himself unexpectedly in Wonderland where he meets Alice.

How did I end up here? I asked to be dropped off in Neverland. Neverland! Not Wonderland! This is such a strange place. Everyone seems a little, well unhinged if you know what I mean? They make Captain Hook look positively sane. I was thinking I could just fly out of here but for some reason there seems to be no magic in this land, I'm a little incapacitated. Where is Tink when you need her? Wait a minute who is that pretty girl over there? Wendy? Wendy it's me Peter. Oops sorry I thought you were my friend Wendy... Oh, well nice to meet you Alice. Can you help me get out of here? Are you a pixie? Do you have any pixie dust?... A girl! My Wendy is a girl, I haven't met many other girls before...You need to get home too. What was that? ...A Queen? Maybe she can help us get home. Wait, she doesn't seem too friendly. What is a guillotine? ... So I'm just going to hide behind this mushroom.

EXTRAORDINARY
Suitability: Pre-teen
Character: Ellie/Eddie

Ellie/Eddie wishes that there was something special about her/him like the others in her/his class.

Staring out with a blank sheet of paper in front of me. That's all I can do, for once I have nothing to say. 'Write a report on your biggest achievement,' Mrs Holt said as she flicked her nose a couple of times. Yes, you heard me right. She has this habit; she holds her forefinger pointing upwards and from right to left flicks the end of her nose. I swear to God that nose vibrates! I can hear it move from side to side as it wobbles as if it's made of rubber. It entertains the class daily and we never get bored of holding our rulers out protruding from our nose, then twanging it as hard as we can. Anyway, we have to write about ourselves, something we are proud of achieving. But what if your biggest achievement is getting up for school on time or making your own breakfast? You see there's nothing remarkable about me. Not like Suzy Norman who wins every race on sports day, her egg has never, and I mean never, fallen off the spoon! Or like Jenny Rae Toussant who can speak two languages and lived in France for three whole years, or like my sister who is literally good at everything. My mum always says, 'She has the voice of an angel,' and she does, I love to hear her sing. I'm not like anyone else. I'm just plain old me who helps Mum around

the house, takes the dog for a walk and likes to listen to the TV. Mrs Holt says if it's easier for me I can do my homework as a recording, but I've been learning braille for the last two years and I won't take the easy way out. You don't become extraordinary by avoiding challenges. So watch out Suzy Norman, I don't have to stick my egg to the spoon to be special.

MY WORLD
Suitability: Pre-teen
Character: Isaac/Imogen

Isaac/Imogen talks about his/her beloved pet Connie and her trip to see the vet.

If I close my eyes, I can see her, it feels real. We are running together through the fields without a care in the world. She is my whole world, she is the only one I can rely on. When we are out in the countryside I feel happy and free, and sometimes when I feel sad she is there for me. A cuddle is all that I need for me to feel me again. My best friend may not be able to answer all my questions, but often it's not answers I need; what I need is a dependable friend and that is what Connie is, or should I say was.

It was a regular trip to the vet, an inoculation which we went for each year. She was healthy or so I thought – perfect in my mind. I stood next to my mum holding her paw, stroking her soft fur, keeping her calm. The vet was friendly, she smiled in a comforting way that took my fears away. Connie seemed unfazed by the needle that headed her way and she didn't even flinch. She was braver than me, I hate needles and I've always cried at the thought of a visit to the doctors, but my best friend was the bravest.

The vet gave Connie a full check-up and asked to speak to my mum outside of the room, I stayed with Connie and I could hear whispering. Later on that day as I was getting

ready for bed, my mum asked to speak to me. She held my hand and I listened to the worst news I had ever heard. A heart defect, she said. My Connie, my world, was sick. No! I don't believe you. Connie is brave and strong and she will never leave me. She's my world! My mum held me tight. Connie was with me for a few months after this and we spent every second together. Then she was gone.

I open my eyes and it is quiet and I am alone. My world is different. Mum said time heals and when the new puppy arrives I'll feel better, but I won't. Connie will never be replaced. She will always be my world, even if now she only appears when I close my eyes.

I WON'T CHOOSE
Suitability: Pre-teen
Character: Robert/Ruth

Robert/Ruth is asked to decide who he/she wants to live with after his/her parents' divorce.

You want me to choose? What? You mean like pick? But I don't want to pick. I won't pick! I love them both, I love them both as much as each other. I love them both the same. I don't want anything to change, things are fine! They're fine. I never even heard them argue, so I don't really know why we are here. Why? Why don't they love each other? They can be friends, can't they? When me and Matilda had a row about whether or not she had lent me the latest Wimpy Kid book - which by the way she had, but I definitely gave her it back - we just didn't talk for one playtime. Then we just couldn't help it, we started giggling at one of Tommy Haywood's silly jokes and that was it, just like that, best friends again. So it's simple really, Mum just needs to laugh at one of Dad's daft impressions and we can all go back to the way it was, and I won't have to choose and I can stay in my house with my family. Please, please don't make me choose.

ALFIE

Suitability: Pre-teen

Character: Ben/Betsie

Ben/Betsie is looking forward to Christmas time and wintery weather as he/she gets to spend time with someone special.

I know we only have a short time together Alfie, but I want you to know that you are amazing, and even though you are deteriorating every day you remain the same to me. I love getting up and seeing your big smile out of my bedroom window, but my mum says you will be gone soon and I should prepare myself. That makes me sad but I'm hoping you will be back next year. Christmas just isn't the same without you. I'm going to buy you a new bobble hat with a matching scarf, I think red would suit you best. Oh no Alfie you've lost an eye, I hope that wasn't painful. I bet that pesky dog next door had something to do with it. Mum always says, 'She's just being playful, she's only a puppy,' like losing an eye isn't serious! And what is that yellow streak down your left side, oh my goodness that just isn't cool and it is certainly not being playful! It's sabotage!

Sometimes I feel like we only have each other Alfie, you're the only one who listens to me and I know how much you enjoy our days in the snow. I don't want the sun to come back, I can't bear to see you disappear for another year. Becoming a puddle is all you have to look forward to and

I bet that dog next door will just love paddling in you, or worse. That animal has no respect.

You may be shrinking in front of my very eyes but my love for you is greater than ever. I am praying for a big freeze next winter so we can be together again, and I promise you this Alfie, I will build the biggest animal proof barricade all the way around you. Playful puppy? I don't think so, more like devil dog! Happy New Year Alfie, see you again next year.

(Aside.) I think I'd better save the global warming chat for another time.

IT'S HERE SOMEWHERE

This monologue is a Grade 1 piece in the LAMDA Anthology Volume 4.

Suitability: Pre-teen

Character: Abbi

Abbi tries to find a letter from school she needs to give her mum, it is lost in the depths of her messy bedroom.

I know it's here somewhere, I can remember putting it away in a safe place. I just can't remember which safe place. What do you mean it's a mess? Mum I've told you I like to organise my room in a certain way. This pile here is my dancing stuff, this here is school stuff, over here is weekend stuff, under there is a box of memories and in this corner is a neat pile of clothes that I've worn but haven't quite had time to transfer to the laundry basket. This over here is a pile of things I might need in an emergency and finally on top of this set of drawers is a pile I've labelled miscellaneous, yes that's right it's basically everything else I own. Mum please don't nag, I'll find it, why do schools send important letters out via the child anyway? I know the teachers are old but surely they've figured out how to use email. Maybe it's in my memory box. Aww Mum look at this! My first ever painting, move over Picasso. And look at this valentine's card. I know you and Dad sent it but made me feel like I was very popular at the time, which – let's face it - is important in nursery school. Mum look, do you remember when I sewed this teddy bear and gave

you it for Christmas, one eye was a cool look for bears in those days. Oh wow! Mum here is Gran's wedding ring, and you thought it was lost. You see I may not be able to locate a dumb letter from my form tutor but I bet you're glad I'm a hoarder now.

I'M NOT READY

This monologue is a Grade 2 piece in the LAMDA Anthology Volume 4.
Suitability: Pre-teen
Character: Evan

Evan enjoys playing the saxophone and attends lessons with Miss Angela who has decided it's time he took his first grade, but Evan doesn't feel ready.

'Turn that music down!' That was my mum's reaction to me practising my saxophone. On a positive note, no pun intended, she thought I was playing one of my CD's, so I must be improving. I love playing my sax, it is so relaxing after a long and slightly boring day at school. When I first started learning it was really hard and I couldn't even make a sound out of it, then I progressed to a squeak, and now apparently I sound like an actual CD. Although Mum has had a glass of wine, so I'll take that compliment loosely. My teacher Miss Angela keeps saying, 'Evan you're ready to take your first grade,' but I'm not. I don't like playing in front of strangers; she tells me there will be just one examiner in the room but even one unfamiliar face makes my heart race, my legs wobble and my saxophone squeak. I'm not sure why anyone would choose to be in that situation. I'm happy just playing my instrument to the four walls of my bedroom and Chip, my hamster, who I'm sure runs around his wheel faster when I play. My mum said she would give me a tenner if I do it, surely that's bribery,

although there is this awesome computer game I've been saving for, so it's worth some consideration. I just need to work on my jelly legs and shaky fingers or I'm going to be hitting all the wrong notes and I won't sound like a CD, I'll sound like a chorus of mice squeaking their way through a poor rendition of Somewhere Only We Know. Mum always says a nice glass of wine steadies her nerves, apparently it's called Dutch courage, so maybe there is an answer to my predicament, yes that's it, I'm going to wait until I'm eighteen to take my grade one examination.

MY GRANDMA NEVER SITS DOWN

Suitability: Pre-teen

Character: Robert

Robert talks about his active Grandma who is always full of energy.

My grandma never sits down. She's always doing jobs around the house but it's not even her house, it's mine. One day she came round and let herself in. She's even got her own key. My grandma also loves to iron, she even irons my underpants, and nobody wants to touch my underpants! People don't even look at them, I don't need my underpants straightened. She says that her job is to look after us but what kind of job is that? When I'm older, well not quite as old as Grandma, I want to be a fast sprinter who beats Bolt's world record. The only record my grandma is going to beat is how many underpants can be ironed in one minute, sounds boring and totally not cool. My grandma has more energy than all the family put together: when she isn't doing jobs, she takes me out for sports, bowling, cinema and swimming. She is also very competitive when we play squash, she always beats me. She says, "I always had the potential to be a professional, but you my boy can be even more." I've always been grandma's little champ; I think I'm her favourite, but don't tell my sister.

Can I tell you a secret? I've been worrying lately, what about the day when grandma gets too old and runs out

of energy? I mean. she says she's going to outlive us all, but what if that's not true? Even though my grandma can be annoying with all the jobs she does, I can't live without my active grandma. I think she has superpowers. Everyone else thinks otherwise, but let me tell you there's only one person who can iron 534 pair of underpants in one minute. In fact, she's trying to beat the record now. 532, 533, 534, 535! Yay! Grandma you've done it. You should probably sit down for a few minutes before you get too tired. 'Tired is not in my vocabulary,' she replies. Yes, I know you've got jobs to do but you've been doing housework for four hours. I don't know how she does it all! Yep there she goes putting more underpants in the washing machine. No wait Grandma not in there, that's the dishwasher.

Written by Evan Watkinson
Edited by Joanne Watkinson

A MERMAID'S VIEW

Suitability: Pre-teen

Character: Madeleine the Mermaid

A mermaid is enjoying the view from her new rock and wondering what it's like on the land.

Hello, Mr Dolphin. I haven't seen you for a while. This is my new rock – well I don't actually own it, it belongs to the ocean, but it's where I like to sit when I watch the sun rise. I sit here and look at the scenery. Do you like it? I wonder what it's like on land. I've heard stories about it, but my parents warn me it's not a nice place. I think it looks pretty from here. The Mer-people are very passionate about the ocean and the Mer-elders tell us that the strange alien objects we find in the sea are put there by the land people. If it's true, then maybe they aren't too nice after all. My friend Shelly was caught up in one of their nets and Fizz my sister once began choking on one of their alien objects. Our Queen Mermaid says that they are waging a war on the ocean, that sounds scary. I try not to worry though; I just like to swim all day and hang out on my rock at night until sunrise. Why are you so sad Mr D? Oh my goodness, that is awful. Your brother was caught by the land people? I'm so sorry. Maybe we could find him, we could go to the land and maybe we will see him. I'm beginning to think the Mer-elders are right. Land people are dangerous. Come on Mr D, let's go for a swim, it might take your mind off it. Then we should visit the Mer-Queen to ask for her advice. We won't let the land people win. I'll race you.

MAGICAL PET
Suitability: Pre-teen
Character: Sophie

Sophie is talking to one of her friends about her secret.

Ssh, don't tell anyone but I have a secret pet. But don't tell a soul because my mum doesn't know about her. You see I'm not allowed to have a pet really. Last year I went to the local fairground and I got to pick a prize from the hook a duck stall. I knew exactly what I wanted, and I even had a name picked out. He swam so fast around his bowl I decided to call him Speedy.

"Please can I have the goldfish?"

"Please Mum, I promise I'll feed him every day and clean him out every week."

"But why?"

I ended up with a plastic spinning top which broke the very next day. I don't know why I'm not allowed a pet, surely it will teach me skills, like caring for others. Mum says pets are an extra hassle she doesn't need. "I didn't have any pets when I was your age." Blah, blah. It's not fair! My best friend Maddie has two dogs, Sam in my class has a whole farm full of animals and you have a kitten.

Anyway, so after a year of pleading I've decided to take matters into my own hands. I've found myself a secret pet. Please keep it quiet. It's a very special type of pet, very

rare. You won't have ever seen one in real life before. If I show you, you'll have to promise not to tell. Okay, hold out your hands. Now open your eyes. What do you mean there's nothing there? What's wrong with you, it's clear as day. This is Ursula my baby unicorn. I'm not a liar, I'm not. You're hurting Ursula's feelings. Stop saying that, she does exist, she does. Where are you going? Fine go home then. Don't be sad Ursula, she's just jealous because she's only got a kitten. You're special and I will look after you forever. I love you Ursula.

COWBOY TRUMPS INDIAN

Suitability: Pre-teen

Character: Ethan/Evie

Ethan/Evie is playing Cowboys and Indians with his/her sister, but everything has to be by Ethan/Evie's rules.

You can't cross the river so stop right there before I take you down with my pistol! Your bow is looking pretty lame right now Indian Joe, do you surrender? What do you mean who's Indian Joe? You are Alice, it's called pretending, now keep up with the rules. Do you surrender? Then let the battle commence! But before we do commence the battle, can I just confirm that those arrows are in fact plastic with a soft rubber end aimed at bouncing off and not perforating said victim? Ok that's fair too, I can in fact confirm that this is not a genuine western pistol complete with lead bullets but a modern-day toy gun with foam inserts, and could not in fact perforate said Indian. Now you stand on your bed and I'll stand on mine, the first one to fall into the crocodile infested river between the two is the loser and will be eaten alive. Don't shoot yet, I haven't said go. Actually, you're wrong, I'm sure that there was some kind of indication in Western times of when the battle should commence. It wouldn't be fair if there weren't any rules now would it? Woah, woah, woah, Indian Chief - you can't just jump across the river and land on cowboy territory, that's not what the rules say. What do you mean? What rules? I'm telling you the rules. Now stay

on your side of the bedroom. Are you ready? And fire! Ouch! That nearly got me in the eye. Mum, Alice nearly got me in the eye. You're going to get it now, take that Indian Joe, a round of bullets just for you. I win! I just do, okay! Cowboy trumps Indian, well it does in my game. Grandpa says John Wayne always wins. I'll be down in a minute Mum, I just need to feed Alice to the crocodile.

WILDERNESS BADGE
Suitability: Pre-teen
Character: Cub

A Cub Scout is trying his/her best to get his/her wilderness badge.

My cub camp leaders all had names from the Jungle Book for some reason, maybe they thought it was all rather cool and outdoorsy. This is my first time away from home on cub camp, I moved up from Beavers last year so now I'm in the big league. Akela has challenged us to make fire out of sticks. So here I am, sticks in hand and not a clue where to start. I'm in Bagheera's team but he just sits there watching and eating marshmallows, which I'm sure were meant for toasting round the fire when it's lit. He's only here to get his Duke of Edinburgh, he doesn't even like kids. I really want my wilderness badge to go with my safety first and my cycling proficiency, but it's looking doubtful. Right, how about we knock them together or maybe scrape them. Bagheera, can you come and help us? Try rubbing them together? That's what we are doing. You're supposed to help us. I don't want a match that's cheating. Oh look, here comes Baloo and his perfect examples of wilderness warriors. You've completed the task already? Wow! That was fast. Yeah I'd definitely prefer to join your team and I'm happy to help build the bivouac. Timmy it's your turn to rub those sticks together, I'll be back soon. Team effort guys, you hear that Bagheera, no Duke is going to give out an award for eating the most marshmallows in one go! Nice try though.

PIRATE NOT PRINCESS

Suitability: Pre-teen

Character: Elsie

Elsie is getting ready for a fancy-dress party but refuses to go as a princess in favour of a pirate.

Look Daddy, I've told you it's very pretty but it's just not me. I don't want to go to the party as a fairy princess – yes I know I'm your favourite princess, but I'm really not the princess type, Daddy. I want to be a pirate, yes, a pirate Daddy, with a shiny sword and a menacing eye patch. Just because Tommy is going as a pirate doesn't mean that I can't, I thought parents liked to dress their kids in matching clothes? We can have matching hats. But I'll have an eye patch and he can have a crutch, you know like Long John Silver, you like that film don't you Daddy? I thought Treasure Island was your favourite. Listen, I can do the voice and everything, aaaarrrrggghhh me hearties, and look at this mean face. Definitely more pirate than princess wouldn't you say Daddy. I'm more the princess-saving type than the whole damsel in distress thing. Okay, well if Tommy insists on wearing the pirate costume and he won't let me borrow any of the accessories, and he wants to be the only pirate at the party, and you don't want me to even be a pirate then there's only one thing left.... I'll be his parrot, I know how much he loves me repeating everything he says, it won't be annoying at all, won't be annoying at all, won't be annoying at all, won't be annoying at all!

FAME CLUB
Suitability: Pre-teen
Character: Joanne

It is the eighties and Joanne and her friends have formed a club based on the hit TV show Fame. Joanne's younger sister wants to join.

What's the password? You can't come in without one. 'Star maker', oh ok you know it, well you will need to pass the test before you're allowed in. Well, it's not up to Mum if you can join, it's my club. This is the best club on our cul-de-sac, and only the most talented can join. Ok let's start, test one, how high can you kick your leg? Hmm, you will need to work on that. Hard work costs you know and right here is where you start paying in sweat. No not literally, oh jeez! The club is free, well it is if you pass the test. Right, test two, what is the club uniform? Yes, a leotard and… and what? Yes tights and… and… leg warmers! You need leg warmers to join my club. Test number three, you need to be able to do an American accent, repeat after me: 'Sure Miss Grant I could add a pirouette.' Well you might need to work on that, the accent and the pirouette. Right the final test is to climb up onto the top bunk and straddle jump off shouting High Fidelity. Hmm, that's pretty good and I could do with another member, right you need to choose a name, no not your own name, one from the TV show. You can't have CoCo because that's me. Terry is Leroy and Jane is Doris, she had to be Doris, she's not a natural dancer. So you can be Bruno or Julie. I'm afraid

you can't be Danny as he's funny and well you're not really the comic type. Right, I'd like to officially welcome you to my Fame club, you will need to go to your bedroom to get your leg warmers but then you can be in my next routine. We're working on a show for Mum and Dad and I'm the star, you can be my backing dancer. It's time to start paying in sweat.

SANTA CAN ONLY BE RED
Suitability: Pre-teen
Character: Melissa/Michael

Melissa/Michael is at primary school. The class are making Christmas cards for a competition and she/he is getting rather frustrated over the missing red crayon.

Right everyone, stop right there. Do not move! Lay down your glue stick, do not sprinkle one more grain of that glitter. Someone here has stolen my red crayon, and I want it back right now. How can I finish my Christmas card without red? Santa can only be RED!

"Calm down Melissa/Michael I don't think anyone would have deliberately taken your crayon, red or otherwise."

This was Miss Meaden's reaction to my outburst. At least that's what she called it when she phoned my mum later that day.

Doesn't anyone understand that there's a thief in the room, it's pure sabotage. I bet it has something to do with Richard Mathews, he has always been jealous of my arts and craft skills. He knows I will win the Christmas card competition, at least I would if I had the right colours. Look at him smirking. Miss, Richard is smiling, it must be him.

"Smiling isn't a crime now is it?" she replied, clearly on Richard's side.

It's a crime to take something that doesn't belong to you though Miss, and look at his picture, it's exactly the same as mine. Even Santa's reindeer is identical to those in my drawing. Richard Mathews is a copycat! And look, Miss his Santa is red... red crayon. What am I supposed to do about Rudolf's nose? Miss Meadon just rolled her eyes and turned away.

Fine if that's the way it is, I'm going to decorate Santa in the most ridiculous colours. I'll show you all. Right, where's the yellow, and let's add some pink, and green, purple and brown. Lots of stripes I think, that should make him look particularly stupid. There you go Miss here's my entry.

"What lovely colours Melissa/Michael, who would've thought to put Joseph and his Technicolor Dreamcoat on a Christmas card, very creative."

An unexpected reaction, but okay let's go with this. Yes Joseph, that was exactly what I was aiming for. Santa is just so predictable. Merry Christmas Miss.

CHECK MATE!
Suitability: Pre-teen
Character: Archie/Annie

Archie/Annie is an only child, he/she compensates for this by inventing imaginary friends to play with. He/she loves winning, particularly at chess.

Being an only child can be great when it comes to getting presents at Christmas but other than that it's generally pretty dull. I spend a lot of time in my room playing chess against all the imaginary friends I've invented. Today's match is against Frank, it's your turn Frank. It shouldn't take this long. He says he is building up to take my queen, but I've planned for this and have strategically positioned my pawns, and my knight is putting the pressure on. Then just like that I take him down. Checkmate! It's pretty easy to win when you're an only child. What about a game of snap Frank? He nods.

He/she begins to turn the cards.

So, are you having a good day Frank? Snap! I win. It's sunny outside, do you want to build a tent in the garden? Snap! I win. We can use the sheet from my bed. Snap! I win again. Then we can prop up some branches like a tepee and drape the sheet over the top. Snap! You're not very good at this game, Frank. Come on, let's gather what we need for the tent and put it in my backpack. So, we need the sheet from my bed and some things to do. Let's

pack the chess board and the cards. I bet there's some snacks in the kitchen we can take too. Right we are ready, let's go. Oh hey Mum - we, I mean I, was just going to make a tent in the garden. What exciting news? Really? A brother! Oh, I guess that's exciting, maybe not such great news for Frank. Who's Frank? Oh, he's nobody Mum. I'm finally going to have someone to play with; I hope he's not very good at Chess.

QUEEN OF HEARTS AND THE BEST TARTS
Suitability: Pre-teen
Character: Queen of Hearts

The Queen of Hearts is a keen baker and her servant the knave has put her forward for a baking competition. She is far from impressed.

You've done what? You've entered me for a TV show? The Great Wonderland Bake Off! Why would I want to do that? It may well sound like fun to you, but I don't do fun! There is no point in me entering anyway as it's so obvious that I would win. What do you mean, how do I know? I'm the Queen and I know everything. Look I don't need a pathetic knave like you to keep me occupied. I can occupy myself. The Great Wonderland Bake Off, what a ludicrous idea! You do that, take yourself off and go and bug someone else, I'm quite capable of finding things to do.

Long silence as the Queen becomes more and more agitated.

Knave! Knave! I demand you attend to me at once!

She starts tapping her fingers on the arm of the chair.

Knave of Hearts come here at once. Ah there you are, I'm hungry! Get me that fresh batch of tarts I baked this morning. They're what? Gone! Tarts don't just vanish, did you steal my tarts? Look me in the eye! You did what? Why in the name of Wonderland would you send them to a TV channel? A sample, a sample! That's ridiculous

why would they need to sample them, I've told you they're the best in the land! I told you I don't want to go on their stupid programme to be told what I already know. I'm the best and that's the end of it, you'll be putting me forward for The X-Factor next. No wait, come back, I was being sarcastic! I can't sing!

NO ONE UNDERSTANDS ME
Suitability: Pre-teen
Character: Noah/Nora

*Noah/Nora is fed up of being asked to do chores around the house.
However, the offer of being paid kicks him/her into action.*

No one in this house understands me! Tidy your room she
says, feed the dog, empty the dishwasher. It's so frustrating.
I have to go to work too you know – well, school, but that's
harder than work isn't it? Getting told what to do all the
time is draining. The teachers are bossy at school and my
parents are bossy at home. Yet they tell me to think for
myself, to have a mind of my own, be my own person.
Well this mind, which belongs to this person, is saying I
shouldn't have to do chores. I'm a kid, kids have fun, and
none of those things are fun. Sorry what was that? For
money you say? You'll actually pay me? Okay I'm feeding
the dog as we speak, come here Patch, teatime Patch. Easy
money! Right let's tackle that dishwasher, why doesn't my
brother ever clear his plate before dumping it in the sink?
Disgusting. He's so annoying. Yes I'm doing it Mum, it will
be loaded in no time, not that difficult at all. Easy money!
Yes Mum my bedroom will get done next. So can I have
my wages? What is that? Ten pence and a mummy cuddle
voucher. My bedroom can stay a mess. See ya.

I LOVE THE ICE
Suitability: Pre-teen
Character: Mia

Mia is a talented ice dancer who has been training hard since she was very young. She has big dreams of becoming a champion.

I have to be here at the rink for 5am. Crazy isn't it, but that's what I have to do if I'm to be a champion. I have to train early when the rink is quiet. Once it's open to the public, there's no chance of any kind of quality training. My friends think I'm mad, training before school and turning down party invitations at the weekends. But no one truly understands how it feels to sail around the rink like I'm floating on air. I love to pirouette and twirl to the music. My coach is looking for a duet partner for me, but it's a competitive world and there are fewer boys than girls in the sport, so they're in demand. They have to want to partner me, so I need to get in as many training sessions as possible so I can prove myself at the regional championships next weekend. I know who I'd like to have as my partner, his name is Harry and he wins everything. I've heard his coach is looking for a new partner for him since Josie Kirby had the accident, she landed awkwardly from a jump and she's having to take a break from the ice. That would be my biggest nightmare, I live for this place, I'd be lost without ice skating. I love to watch old clips of Torvill and Dean, their Bolero routine is my favourite, and I dream that one day that will be me, and hopefully Harry.

I want to stand on that Olympic podium and know that the National Anthem is playing for me. Anyway, I must stop chatting and get training. These boots aren't going to lace themselves up.

POOF!

Suitability: Pre-teen
Character: Shaun/Sherry

Shaun/Sherry is out in the woods trying out their new metal detector. When he/she finds something quite unexpected and almost all his/her wishes come true.

Why on earth did my mum think this would be an exciting present for someone my age? I've been out here for half an hour and it hasn't beeped once. Maybe the batteries aren't working, last Christmas I got this cool robot and mum put the batteries in the wrong way round. Let me see…

He/she removes the battery cover.

No, it appears she got it right this time, there's obviously nothing interesting to find. One more try… You'd think there would be something like an old… yes, finally… an old coin. Ah but not even one I can spend it's so old. Well at least it's a start and whoa! There it goes again I am on a roll. I can't see anything, lucky I packed a spade, well a small trowel that I found in the shed.

Starts to dig.

What is this old thing? It looks like my gran's gravy boat only metal of course, it's so dirty. I'm well equipped today though, where's that cloth? Ah right let's clean you up.

Suddenly he/she jumps back with surprise.

Oh wow are you real? You look real. I'm assuming you are a genie who has come to grant me three wishes like in the fairy tales. Well that's great, who'd have thought it? My own real-life genie. To be honest with you, when I got this metal detector for my birthday, I was a bit disappointed, "It will get you out of the house," my mum said. "Very thoughtful Mum thanks." Not exactly the iPod I'd asked for but, so I didn't appear ungrateful, I headed out to these woods to give it a go. Next thing I know POOF! And here you are. My friends will be so jealous. Anyway, let's get down to business, so my wishes, let me have a little think. Well I didn't get an iPod did I? So that will be my first wish. No way just like that poof and it's in my hand, you're good. Now for my second wish, how about for my little brother to quit bugging me, I suppose I'll find out later if that one's worked. Are you happy being a genie? Because you know I guess my last wish should be to release you. That would be the right thing to do wouldn't it? Oh really, darn it I really wanted a cute little puppy.

CIRCUS DOG
Suitability: Pre-teen
Character: Zac/Zoe

Zac/Zoe wanted a dog, but the deal was to attend doggy training classes. He/she attends for the first time with quite unexpected results.

Come on Tessa this way, good girl, now sit. I said sit. Just sit. Just sit on your bum, then you can have a treat. Please sit. It's not difficult, just sit like this! Oh hi, sorry, I didn't mean to raise my voice. Yes, we are new to this, my mum said if I get a dog, which I begged for... for two years straight, I would have to take her to doggy training classes. So here we are, but it's not going too well. Watch this.... Tessa, fetch! You see, she runs past it. She just wants to play with the other dogs, and she only comes back to me when *she's* ready not when *I* call her, it's so frustrating. Sure, give it your best shot, her name is Tessa. Wow! How did you do that? Ah right okay, so I just need to change the tone of my voice. "Tessa come here Tessa." *(In a softer tone.)* "Tessa come on girl." *(Getting frustrated.)* "Tessa get here right now!" *(Walks to the dog, pointing.)* "This way dumb dog!"

She just doesn't get it, I've brought all these meaty treats for her and nothing is working, she's just not interested. Fine I'll just sit here and watch all the other obedient dogs whilst mine plays the class clown. So here I am sat in a room full of clever, obedient dogs of all shapes and sizes,

feeling a little awkward. I don't regret nagging Mum for a dog. I love Tessa. I just feel frustrated that I am the proud owner of the class rebel.

Hang on, why is everyone clapping? Where's Tessa? Oh no I've lost her. Why has everyone formed a circle? "Tessa! Where are you girl?" Excuse me what is everyone doing? Is this how we end the class? A circus dog doing tricks?

Making his/her way through the crowd.

On my goodness, it's Tessa. I didn't know she could walk on her hind legs and... and... do a flip! Wow! My Tessa is a big hit, good girl Tessa, top of the class.

SHOW AND TELL
Suitability: Pre-teen
Character: Robbie/Ruby

Robbie/Ruby attends class one morning only to discover it's 'Show and Tell' day and he/she has forgotten to bring anything for their presentation. He/she puts a plan into action which almost backfires.

I entered the classroom and my heart immediately sank, oh no it's Friday, show and tell. I completely forgot. What shall I do? I haven't brought anything. Quick scan of the room: okay so Jody Monroe has brought a trophy, Max Hilliard has got what looks like a remote-control car, Simon Benson has brought a certificate and I currently have nothing, absolutely nothing to show. Wait, where is Suzy Williams? She's not here; great I'll just slyly unpin her piece of artwork from the wall and pass it off as my own. Perfect. So here I am sat cross legged on the floor listening to everyone else's really uninteresting speeches about some frankly dull objects. Right so I'm next, here it goes. As I stand, I can feel all eyes on me, and my heart skips a beat.

I'd like to show you all a very special piece of artwork, this is erm ... Abstract. I like abstraction because it can be interpreted in lots of different ways. When I look at it, I think of the seasons, this is the sunshine over here and then we have leaves, daffodils and a white area here which represents snow in the winter. Suddenly like a

bolt of lightning Suzy Williams marches in through the classroom door. "Sorry I'm late Miss." Right what do I do? Let's shut this down as quickly as possible. So I'd like to thank you all for listening to my presentation, I go to sit down but it's too late.... "That is my artwork! Miss s/he's showing my work not his/hers. You're a cheat; you're a cheat, cheat, cheat." She's chanting and the rest of the class gasp. My cheeks redden. Feeling like a suspect on trial I rise to my feet, damage control needed. Excuse me miss I would like to continue with my presentation, as I said before I like the abstract style of this piece, not at any point on my presentation did I claim this was my work, *(under his/her breath)* thank goodness. I wanted to use this fabulous artwork for my show and tell because I think it's important that we appreciate each other's achievements, and Suzy is clearly a very talented artist. I'm sorry I didn't ask your permission first Suzy, but I hope you'll forgive me. Gradually the class rises to its feet, every single person, including Suzy Williams. They begin to clap, I take an awkward bow and edge my way off of the stage. I pin the artwork back up and let out a huge sigh of relief. As I turn Miss Bains is stood looking down at me. "Well done, that was a very uplifting speech, but next time come prepared. You got away with it today, but you can't wing everything in life." Smiling awkwardly, I sit at my desk; she's like Miss Marple that woman, nothing gets past her.

I'M NOT CONTRARY
(From the play **Fleeced**.)
Suitability: Pre-teen/Young Teen
Character: Mary Mary Quite Contrary

Mary Mary is not happy. Her precious garden has been vandalised and she is venting to King Cole.

I'm not mad, well I am a bit. Not mad crazy but mad angry. I've been growing my plants in this garden for the last six months, and I wake up to find this mess. Wrecked it is, vandalised! Do you know how hard it is to grow cockle shells, not to mention silver bells? Of course you don't, I'm the only one who does, well almost the only one, no definitely the only one. It has taken me months, well years, no definitely months, to find the right substances to make silver expand and grow. And there are clearly jealous people in Nursery Rhyme Land who think destroying something that a person has worked for is acceptable behaviour. What about your little Neighbourhood Watch thing you've got going on? Little Bo Peep loses her sheep and suddenly the whole land is running around, pulling together, but serious vandalism occurs and you sweep it under the carpet - your very royal, probably red carpet. You don't care about regular people like me; you don't like people with an opinion. This was going to make me rich one day, well maybe not rich, maybe comfortable, no actually I was right the first time! How many people do you know who can grow silver? It was going to make me

rich, richer than you King Cole, stinking rich, so I could leave Nursery Rhyme Land once and for all. No I can't just let it go! In fact, I bet this has something to do with Bo Peep's precious little sheep. You're supposed to rule the land, so rule it! Put rules in place! There should be a warrant out for their arrest. I'm not being difficult, I know what you all call me, but I'm not contrary I'm angry, know the difference and do something about it. I want my garden back to its original state complete with cockle shells, silver bells and if I have to get a row of maids, pretty or otherwise, to tend it, I will!

GRAN SAYS
Suitability: Pre-teen/Young Teen
Character: Ethan

Ethan takes advice from his Gran about a girl he likes at school.

Gran says that actions speak louder than words, so why is it, despite a dozen red roses and a love letter that took me three whole days to write, she still hasn't said one single word to me? I've even given her a diamond ring - well a diamond-looking ring, my pocket money doesn't stretch to the real thing - but my gran says it's the thought that counts. Maybe living with Gran has made me a little old fashioned, but she says I'm a gentleman and my mother would've been proud of me. So how is it that my actions are not speaking to Sophie Louise Jeffries? I left the flowers by her locker, she couldn't have missed them, I'd decorated the label with her name and different coloured hearts, that's what girls like, don't they? Do you think she will ever want to go out with me? Yes but you would say that, you're my gran. But am I handsome in anyone else's eyes?

I posted the love letter straight through the letterbox of her house, it's one of those outside ones with a little key to unlock and retrieve your mail. I know she received it because I hid behind the bushes of the house next door and waited. Her mum opened the mailbox and I heard her shout, 'Sophie you've got mail and it's covered in pretty

little unicorns.' I'd heard from Katie Sue that Sophie liked unicorns and all things mystical. So I know she got it. Gran do you think the ring was a step too far? She didn't have it on at school today, I know because I followed her to her form room. I pretended I had a message for her teacher. Gran, am I coming on too strong? Did Grandad send you nice gifts? So it worked for you, he sent you letters every day during the war and you replied to each one, didn't you? You must've really loved each other, maybe you could show them to me. I could get some much-needed inspiration from them. What did you say Gran? I've got mail. It must be from Sophie, my first ever love letter. *(He opens the envelope.)* Gran, what's a stalker?

EVACUEE

Suitability: Pre-teen/Teen

Character: John/Jane

John/Jane is an evacuee who is making the train journey to meet the people who will be taking care of him/her whilst the war continues.

I stood on the platform feeling terrified but putting on a brave smile for the benefit of my mother who wasn't as good at covering up her sadness. I could see the pain in her eyes. The journey on the train was long and quiet, everyone wrapped up in their own thoughts, their own heartbreak. Mother had promised it was only going to be for a short time, but I wasn't sure, I hadn't been away from mother for even one day in my whole life. I had got used to not seeing father with the war taking him away, taking all the fathers away. Mother and I had always been there for each other in my father's absence and I worry about how lonely and scared she will be without me to care for. I will write to her every day and draw her pictures of the countryside, of the cows, tractors, endless fields and all the other things I will be seeing for the first time.

The train pulled up to the platform slowly as we arrived in Yorkshire, our new temporary families lined the station platform and I disembarked wondering which family would be mine, at least for the foreseeable future. I can't help but look around for the friendliest face in the hope that they will be my new hosts. I scan the line of adults

before me and their children, then I spot her, she's the most beautiful lady I have ever seen. She has a lovely welcoming smile and I quickly pray. Dear Lord, just a quick prayer to ask you to let this beautiful and friendly lady reach out for me. I think we are a perfect match and I would really appreciate it if I could go and stay at her home. Amen.

She steps forward and I hold my breath. Please call my name, please. But she doesn't and my heart sinks with disappointment.

FLEECED

Based on the play of the same name.
Suitability: Pre-teen/Young Teen
Character: Bo Peep

Bo Peep has lost her sheep Barbra and Bartie, she searches Nursery Rhyme Land and meets several characters along the way.

Hello Humpty, have you seen my sheep? Oh dear it's not like them to just wander off like this. *(Calling:)* BaaaaaaBra, BaaaaaaBra! Oh dear, Barbra doesn't like the cold and she will be so frightened, and Bartholomew is afraid of the dark. I must find them before the sun goes down. I thought you might be able to see them from your wall Humpty, please will you keep a look out for me and if you see them let me know egg-sactly where I can find them. Oh no Humpty it wasn't an egg joke I promise, I wouldn't be yolking at a time like this. *(She giggles.)* Oh Humpty, cheer up old fellow, you have a very important job to do and you could be the hero of the story. Thank you Humpty, now I really should be on my way, stood here chatting to you won't find Barbra and Bartholomew now will it? Baaaaa-bra, oh Baaaa-bra, Bartholomew! Come out, come out whereever you are. Oh hi Miss Muffet, have you seen my sheep? Someone stole your curds and whey? Oh my! Well I can assure you that Barbra and little Bartie don't like curd. But maybe Humpty saw the culprit from his wall? Goodbye. Well there is only one last thing I can do; I will have to call the authorities. *(She takes out her phone.)* Is that

the home of the king's men? I request your immediate help, I seem to have misplaced my sheep and I'm getting rather concerned about their whereabouts. Immediately? Well that is a fantastic service, I appreciate it. I will call you back in a little while. Baaa-bra, Bartie! Oh dear, where could they be? Oh hello Mr Cow, I don't suppose you've seen any sheep wandering in the fields? And by the way congratulations on your world record jump. The Moon! I say Mr C, that is impressive. But I'm sorry to hear about Dish, I know you two were close, but if you ask me if I'm surprised? Well, the truth is no, I'm not. Dish and Spoon were a match, it was inevitable. Anyway, I can't stop to gossip, I must find my sheep before dark. *(She pulls out her phone.)* Hi, it's Bo, I'm just wondering if you have had any luck with finding my beloved sheep? Oh my days! Yes, I completely understand. Mr Cow, you will never believe it, such tragic news. On the way to look for Barbra and Bartie, all the king's horses and all the king's men found Humpty in a state of disrepair, they think he's taken a tumble off the wall and is in pieces. They are doing their best to put him back together and egg-stract the evidence. Oh my, no time for jokes Bo. I think I'll go home and knit him a get-well jumper, suddenly missing sheep don't seem quite so important.

WINNER

Suitability: Pre-teen/Teen

Character: Fiona

Fiona is a budding athlete preparing to race her rival.

I hear the voice of my coach in my head: 'Fiona, don't be psyched out by anyone.' Right, Fiona, stay calm, you can do this. But as I look around at the other athletes, I feel the butterflies start. Stay focused and keep stretching! I feel her eyes on me. Then over she comes over, or should I say struts. 'What's your PB?' I look up and, without thinking, 'Actually my new personal best will be performed today.' Did you hear her tut at me and walk away? Less of a strut now, Abigail Asquith! I have no idea where my newfound confidence has come from. Okay so it was verging on cocky, but I've had years of that from her, and she has successfully psyched me out on most occasions. Well this is it, time to make my way to the line. I keep telling myself I can win, but self-doubt is pretty strong, and it niggles at my newfound confidence. I'm having an exhausting internal battle as the starter holds up his pistol. Look at Asquith glancing across at me from lane three. Maybe, just maybe she actually feels a bit threatened. As we enter the starting blocks, I feel strong and powerful, I'm going to bring you down Asquith. Fiona Steadman is the only winner of this race.

LOVES ME, LOVES ME NOT
Suitability: Pre-teen/Teen
Character: Emily

Emily is in love with Tom and is trying to work out if the feeling is mutual.

He loves me, he loves me not, he loves me, he loves me not, he loves me, he loves me not, NOT! Dumb flower. I don't need a dumb flower to tell me what I already know. I mean, the way he looks at me across the playground, it's as if I'm the only girl in the world. He picked me for his team in games last week. Ok, so he didn't pick me first, but I guess he didn't want to make it too obvious. Alright, alright, so he didn't pick me second or third, but I was the first girl to be picked, so really that says it all. In class the other day, Miss said, 'Emily, what is the answer to this sum?' She pointed to the white board and my hands started to sweat, I could feel my heart racing. The numbers looked so jumbled and my brain wouldn't think, all eyes were on me, I heard giggling from behind me, but there was no answer I could muster up. Then suddenly I heard the most beautiful voice, 'The answer is one hundred and twenty-seven, Miss.' 'Thank you Thomas,' said Miss Dobson. I felt a sense of relief and now my heart was beating fast for another reason. I knew it: Tom Barnes loves me. He came to the rescue, my hero saved me from total humiliation. A boy would only do that if he liked a girl, right?

Only two weeks until Valentine's Day, I've started work on Tom's homemade card, then he will know how much I care. I'm looking forward to seeing what he gets me, a chocolate heart maybe? Or a great big teddy bear with the words 'be mine' embroidered on the front? I'm so excited, I'm going to get my first ever boyfriend. You see, dumb daisies can be wrong.

THE LIGHT
Suitability: Pre-teen/Teen
Character: Noah

Noah has witnessed an unidentified flying object, which he believes abducted his brother, but no one believes him.

What is that? Can you see it? Cal, look in the sky. It's so bright, it's hurting my eyes. It's turning the dark skies white. I think we should hide, quick, crouch down behind this. Now stay here, I'll go get Mum. I won't be long, I promise.

Mum come out here, there's something flying in the sky. I'm not making up stories, I promise. It's a bright light, it's not a shooting star, I'm not crazy. I know what a shooting star looks like and this is so much bigger and closer to the ground. You need to come quick, Cal is hiding in the garden. Come on, quick. Fine! No one around here ever believes me.

Cal, Cal, can you hear me? Where are you? Please Cal answer me, where are you? Mum, Mum Cal has gone and so has the light.

My brother was found the next day by the police who had been out searching for him all night. He was found asleep near the lake which was two miles from our home. At first the police said he must've wandered off, then they decided he must've been abducted and left for dead by the lake. No one believed my story: he had been abducted that night,

but the perpetrator wasn't from this planet. Cal was five years old, he was a happy kid. My funny little brother who liked to make people laugh. Only from that day forward, the laughing stopped. He stopped communicating altogether. The police took numerous phone calls about the strange object in the sky that night. But they didn't believe that Cal had been abducted by aliens. The case was filed as unsolved.

The hardest thing to deal with is the disbelief when I try to explain what I saw. I relive those moments every day when I look into my brother's eyes. I know the truth, and it's out there somewhere. They took my brother away from us, not just for the night, they took his soul forever. Until he is prepared to speak we may never know what truly happened to him, but I know what I saw and it was no coincidence that the same night the light almost blinded me, my little brother disappeared.

I DATED AN ELF
Suitability: Pre-teen/Teen
Character: Rosie

Rosie has started dating one of Santa's helpers, but it is not going to plan.

Now don't get me wrong I really do love the holiday season, I love all the decorations, the lights, the presents and the good cheer. I am even partial to a little tipple on Christmas day with all the family. I love the whole Christmas dinner thing, the turkey, stuffing balls, parsnips, even sprouts and the often-hilarious game of charades after the Queen's speech. To be honest there is nothing better than a bit of snow outside, while curling up inside by the log fire. You just can't beat that cosy feeling. I adore everything traditionally Christmassy, and as the song famously says, I wish it could be Christmas every day. But let me tell you, right now I have never felt more frustrated! There is no snow, my log fire has gone out, and I feel extremely unchristmassy, if that's even a word. You would think that someone who considers Santa amongst his closest friends would be on time! If Santa was this abysmal at timekeeping then there would be some very unhappy children across the world, and right now I'm one unhappy and slightly annoyed girl. I don't feel much like decking the halls or jingling any bells, if anything this should be jingling alarm bells in my head! I should've known better than to start dating an elf, Christmas this, Christmas that.

always preoccupied with Christmas. Don't get me wrong, I love the festive season as much as the next person, probably more, but when it comes to going out, I expect my dates to at least show up on time. Well at least I know what to get him for Christmas... a watch!

THE BREAKUP
Suitability: Pre-teen/Teen
Character: Sam

Sam is trying to deal with his/her parents' breakup.

'You're allowed to be angry,' my mother said. I don't need her permission. I don't feel anger, I don't feel sad. I feel nothing! Just emptiness mixed with a feeling of betrayal. Betrayed by the people I love the most, the two people I most rely on. But now there weren't two people to rely on and trust, there was no trust, not anymore. They didn't trust each other, they didn't even love each other, so how could I trust them? Now there was just me; I could only rely on myself.

How could you do this? You've ruined my life, you've ruined our family. I don't want to live in two houses; I don't want to move anywhere. I want to stay in my bedroom, in my house, in my village. I want to go to my school, with my friends where I'm happy. Please Mum, don't do this. Can't you just try to get along? I promise to be well behaved; yes, I know it's not me Mum, I know it's not my fault deep down, but then why does it feel like it is. Have I been too much of a handful? Too loud? Too annoying? Too much in the way? Have I? Because I can change and then Dad will come home and we can be a family again, just the three of us. Don't tell me I will understand one day, because I won't! I really won't!

You just need to remember the good times. Christmas, that was a happy time, last Christmas when you bought Dad that gold watch, he loved it remember? He always wears it, even now. And he bought you that perfume, your favourite. You still wear that don't you? Stop treating me like I don't understand, I do understand. I know what Dad did, Mum, I heard you arguing. He said he was sorry, didn't he? Didn't he? Forgive and forget, that's what you've always told me. Please Mum just forgive him, I need you both.

THERE'S NOTHING MERRY ABOUT ME

From the play **Fleeced**.
Suitability: Pre-teen/Teen
Character: Old King Cole

Old King Cole is in a therapy session to address his feelings about being a royal.

Okay, let me set the record straight, the name is King Cole, so can we have less of the 'Old!' And while I'm at it you may as well know there's nothing merry about me. Oh I'm so sorry, did I burst the majestic bubble? Well, let me tell you, I fulfil all my royal duties with a big fat smile on my face and a polite royal wave. I stop to talk to the people, I'm well-spoken and think carefully about every sentence so it doesn't come back to haunt me, but what I'm really thinking about is... is... how I'd like to be sat at home watching Netflix with a cup of cocoa and some fried chicken.

So here I am talking to you, knowing you can't do a thing about it. Therapy can't work on royalty can it? Because let's face it, I'm not allowed to change. There's the real me and the royal me, two personalities! It's draining pretending to be a merry old soul. To tell you the absolute truth – because let's face it, that's what I'm supposed to do when I'm talking to you, right? – I'm miserable. The only people on this planet I can call friends are three fiddlers, Tom, Dom and Derek, and they work for me at the palace, so

they don't really count, do they? They're friends because they're paid to be. I can't make real friends because I can't leave the palace without a whole lot of pre-planning and an entourage Beyonce would be proud of.

Am I lonely? Have you not been listening? I'm trapped in this world of royal visits, of minding my P's and Q's, of misery. It's a fake world. And I'm expected to find this perfect wife, a suitable Queen. Perfect? There's no such thing. Every girl I meet is only interested in jewels and living in luxury. I don't want luxury, I want normal. I need to know what it's like for my soul to feel merry. What even is merry? And as for old, I'm certainly not OLD! The only old thing about me is this fake old smile that I carry around day in, day out. But believe me there is nothing in my world to feel happy about. As I said before, there's nothing merry about me.

GERONIMO!

Suitability: Pre-teen/Teen

Character: Tom/Tia

Tom/Tia is preparing to do a bungee jump to impress his/her friends who have dared him/her.

You can do it, you CAN do it! Stay focused. Eyes open? No definitely eyes shut. I can't believe I've let them persuade me, when will I learn that accepting a bet does not turn out well. *(Shouting below:)* I will jump, when I'm ready!

Okay, breathe. I'm ready, I am ready. I'm going to do it... Any minute... After three... two... two... two... *(Turning to the extreme sports tutor:)* So the elastic can hold a tonne you say? And it's never snapped before, right?

I remember as a child, my mother taking me up a lighthouse to see the sights, all those steps, climbing higher and higher as my heart raced faster and faster. I never did see those views she talked about, my eyes were tightly shut. A bit like now, I can't look down because if I do my heart may actually stop!

I can feel my friends all staring up at me; they think it's all really funny. They always dare me because they know I'll attempt it. Not because I want to but because I don't want to lose face. You see I want them to like me; I want them to think I'm cool. I mean I'm not... cool that is. I'm very uncool, at least I was at my old school. When I moved here to Devon, home of extreme sports, I decided I wasn't

going to be that geeky kid anymore. So you see, I feel like I have something to prove. So I will jump, I think, and I won't lose face, but I will keep my eyes tightly shut. Ok I'm ready. One, two, Geroni… No! No! It's so high up here.

One, two, Geronimmmm…No! Don't lose face, do not lose face.

One, two, Geroni… I think I'll just stick with being the local geek.

IF WALLS HAD EARS
Suitability: Pre-teen/Teen
Character: Superhero

A superhero shares his frustration over the power he/she has been given and wishes for the power of invisibility.

'If the wall had ears,' you've got to love that saying. It basically refers to overhearing all the gossip that is better left unheard. Unfortunately not an option for me: with my extra-sensory hearing, I can literally hear a pin drop in the next town. I hear conversations overlapped with other conversations, it's noise, a whole lot of noise. But apparently, according to my wacky professor of a dad, I should be grateful for the superpower I've been blessed with. Seriously it's not my power of choice, top choice has to go to invisibility. My dad reckons he's working on this and it might be a possibility in the future. I'd like to go there, the future I mean. My best friend's a time traveller, he's been every place you could imagine, often getting himself in sticky situations. But he definitely has more fun than me. I get to listen to gossip! Boring. My dad thinks I don't know, but I'm totally aware that he's training me up to be a spy. Which is about all my power is good for. I'm also acutely aware that my mother is seeing Jeff from next door, my big sister has a secret boyfriend my parents don't know about and my teacher has a drinking problem. I'm not sure I'm going to save the world with any of these revelations. My 'gift' as Dad calls it is a curse, and I dream

of the day he invents invisibility, because then I'm out of this crazy place. Sometimes superheroes aren't so super, they're pretty ordinary with a whole lot of noise in their head. It would be so much simpler if walls did have ears, then there'd be no need for spies. Although my dad says they do and apparently it's something to do with someone's big brother, who, according to him, is always watching. Not sure whose big brother that is, but his superpowers sound as dull as mine.

CARAVANNING
Suitability: Pre-teen/ Teen
Character: Delia

Delia goes on her first caravanning trip with her family but is far from impressed.

You've booked a holiday Mum? Yes! That's so exciting, we haven't been on holiday for years. Somewhere hot I hope, I'll start packing. Wait, what? Did you say a caravan? What, all of us? You are kidding me, aunt Helen too and all my very annoying little cousins. But I don't want to sleep in a glorified tin can. I want a hotel with a proper bathroom. Where will I put my make-up on? And I need my bubble baths. Oh really? Great. So if I'm not sleeping in the caravan where am I going to sleep? A tent! Erm, no I'm not. Why do I get the tent? That's not fair, why should I have to look after my cousins? Well it sucks being the oldest, and this is going to be the worst holiday ever.

Delia is pitching a tent.

I cannot believe I'm doing this. My jeans are getting dirty, and my arms are aching, this hammer just isn't working, the pegs aren't going in. You're very wrong Mum, this is not going to be the making of me, it is not a defining moment or life-affirming. It's humiliating, what if someone I know sees me, I'll be a laughing stock. I don't want to be outdoorsy, I want to be indoors, cosy and warm in a room with an en-suite. This is not a holiday, it's pure torture.

She spots a handsome young boy.

Who is that? He works here? Oh right, I wonder what he does. Oh right, an activity leader. Oh erm hi, my name? Ah yes, I'm Delia but my friends call me Dee. Sure I'd love to take part, build your own bivouac, that sounds like fun. Okay I'll see you later, bye Daniel.

Right I'm done with this tent, Mum, I haven't got time to finish putting this up, I've got an activity I'm booked onto in half an hour. You know, getting involved and all that, seizing the moment. Getting all outdoorsy. I'm not exactly sure what it is but Daniel said it will be fun. Something about building a bivouac, what is a bivouac exactly? A home-made tent! Oh great!

ANGRY WAVES
Suitability: Pre-teen/Teen
Character: Julie

Julie is thinking back to that fateful day when she lost her father to the sea. She expresses her love for the seaside despite the turmoil it has caused her.

I love the seaside, whatever the weather. The sound of the waves crashing against the cliffs on a windy day, with my parka zipped right to the top. Like a submarine, I peek through my hood and watch the angry tide crashing hard onto the rocks. It reflects my own turmoil whilst somehow soothing my pain. I was only five when it happened, he was just doing his job. My father loved every second he spent upon those very waves, the angry waves, the calm waves, it didn't matter. If he needed to go, he went, and I was proud that it was my daddy steering that boat. Never once did I worry that he might not come home. He was my hero, my superhero, the town lifesaver, and if that bell rang, he was the first there.

I woke up early that morning, with a start. My teddy wasn't next to me, he had fallen on the floor and I felt a sudden wave of panic. I rolled onto the floor with a crash and reached for him, pulling him close. I had this thing when I was little where I imagined my bed was the lifeboat and the carpet was the sea. I scrambled to safety with teddy in my arms. I wasn't scared of the sea, I just knew how it

could behave. I was glad my daddy was there to keep us all safe. My mum came in with my favourite drink, a hot cup of cocoa. I remember thinking that this was strange as I had only ever had cocoa at bedtime. She sat on the edge of my bed and put her comforting arms around me. I felt butterflies in my tummy.

"Honey, you know how brave Daddy has always been…" She had such a comforting tone to her voice, she went on to tell me how the bell rang during the night and…

She didn't need to finish. I felt the pain rush through my body and stab me hard. I held her tight. Teddy fell to the floor once more but this time I didn't reach to save him, I wanted him to be with Daddy.

So here I am years later, staring down from the clifftop, the place I come when I need peace. When I need to talk to my dad. I don't hate the sea as some may think I should, although I still get angry sometimes. I find it comforting because he loved to ride the waves, it's where he felt free. The seaside is a big part of me, now more than ever.

LIFE IN BLACK AND WHITE
Suitability: Pre-teen/Teen
Character: Charlie

Charlie is visiting his/her grandmother, however she is a little confused and hard of hearing.

Hi Grandma, how are you today? Come and look out of the window, it's so sunny – no Grandma it's not funny, I said it's sunny. I'm talking about the weather, *(exaggerating the pronunciation)* the WEATHER. No not Heather, it's me Grandma, Heather's my mum, your daughter. Come and sit beside me. Is that your photo album? I'd love to see old pictures of you and Gramps when you were younger. Was this taken at your school Grandma? When I think of you at school, I think of a place that was totally black and white, that's funny isn't it, Grandma? Yes, it's still sunny, I said that's funny isn't it? Oh it doesn't matter. So do you want something to eat or drink? No Grandma I'm not here to unblock the sink, I'm your grandchild Charlie and I asked if you'd like a drink. I could make you a cup of tea, no Grandma I'm not suggesting you should go for a wee. I know you are in control of your bodily functions you don't need to tell me that, I wasn't suggesting you had a wee I was suggesting you had a cup of tea. Do you think we should turn that hearing aid up Grandma? You seem a little confused today. Where's Alf? Grandma are you ok? Gramps died three years ago. Yes, I know he was in the war Grandma but that was a very long time ago.

World War Two. Oh no that's not what I mean Grandma I know you don't need a... I said two. World War Two. Oh dear. Shall we listen to some music on your record player? These are back in fashion Grandma, I got one for Christmas last year. What about some Vera Lynne? You like her. "We'll meet again don't know where don't know when," that's lovely singing Grandma. No I'm not Vera Grandma, she's singing on the record, I'm Charlie. You remember me, don't you? I'm your grandchild, I've come to visit. Shall we go for a little walk in the sun? I know we've had a nice little talk, and it's been fun, but I wondered if we could now go for a walk, outside in the sun. Yes Grandma it would be fun. A walk, or a talk, in the sun or not, it's always fun with you. Sorry I didn't mean to shout, it's just... it doesn't matter. No Grandma I know you're not deaf.

UNSINKABLE

Suitability: Pre-teen/Teen

Character: Lizzie

Lizzie is excited to start a new life in America with her family and not knowing the fate that awaits her as she boards the Titanic.

I looked up in awe; it was a thing of beauty, stunning in every way. Simply breath-taking, and I could hardly contain my excitement as I stepped aboard with Mother and Papa. We were so lucky to get this opportunity, to be part of this maiden voyage to the land where dreams are made. The first few days were a little uneventful, but we met lovely people and I told everyone what America had in store for me. I was fortunate enough to meet a kind young boy on the deck and we became friends, he listened to my plans for the future.

Hi, do you mind if I sit here for a moment? My parents are unpacking over by the bunks. My name is Lizzie, short for Elizabeth. What's yours? Jonathan, that's a lovely name. We are going to America; Papa said it's where dreams are made. I'm going to seal my dreams on the stage there, just like Ziegfeld Follies, I've read about them in the magazines. My favourite performers are Josephine Baker and Fanny Brice; all the girls are beautiful, beautiful like this vessel. I wonder what it's like on the deck above, pure opulence I bet. I can imagine the ladies in their glamorous dresses, dancing and moving elegantly across the ballroom. I'll be

able to travel like that when I become a star of the stage, at least that's what happens in my dreams. Sorry am I talking too much?

I'm here Mother, this is Jonathan, he's here with his grandparents, they're starting a new life in America too. Where are your parents Jonathan? Oh gosh I'm so sorry, I didn't mean to pry, that's so sad, really tragic, I'm very sorry. Well I guess I should get back to the sleeping quarters, maybe we can meet up tomorrow. Goodbye.

Papa, I've made a friend, he's called Jonathan, he's starting a new life in America too. Isn't that exciting? Maybe he can see me perform in the Jardin de Paris. My head is not in the clouds Papa, my head is in the stars. I can visualise my future dancing on all the famous stages of Broadway.

There is a jolt and she is thrown forwards.

Papa, what was that? My feet are wet. Mother, where is mother?

There is another jolt and Lizzie falls to the floor.

HAPPY PLACE
Suitability: Pre-teen/Teen
Character: Jamie/Jayne

Jamie/Jayne's grandpa recently passed away; he/she is visiting his beloved allotment, a place where Jamie/Jayne feels safe and happy.

This allotment was my grandpa's favourite place, I used to meet him here every Sunday morning and we would plant seeds and tend to the vegetable patch. He used to say it was the place to come if you want to forget all your troubles. He was right, and I come here often. I don't much like school, it's not what I imagined it to be. It makes me feel stressed and anxious. It's not just the pressure of success, it's how I feel about myself when I'm there that gets me down. The kids all think I'm weird. I don't know why, I'm pretty average really. So you see no one really talks to me or bothers to get to know me. So I come here, it's my safe place, my happy place. Only it's not quite the same since my grandpa passed away. He was my best friend and the only person who really understood me. I used to love all his wartime stories, some were sad but most of them were uplifting, about how everyone came together. I wish for that now, not a war but people being there for each other. That certainly isn't the case at my school, it's every kid for himself, unless you're in the popular group, which I am not and would never wish to be. I like being different, I like being here. I like being alone sometimes, but I don't like not seeing Grandpa. But as I kneel here

with my trowel digging the soil to make room for my next set of vegetables, I think of him. Sometimes I think I see a glimpse of him waving to me from across the allotment, I feel like he's still here for me and that gets me through each day. Wait what's this?

His/her trowel hits something hard in the soil.

A tin box, how strange, could Grandpa have planted it here?

He/she opens it.

Wow, look at this old watch and this ring, looks like a wedding ring. There's a letter with it.

Dear Jamie/Jayne,

I leave you this watch and my wedding ring for your safe keeping. They meant a lot to me as your gran gave me them both. Keep them safe and keep my allotment tidy, this place is yours now.

He/she puts on the watch.

I promise, goodbye Grandpa.

DYSTOPIA — THE TASTE THAT ONCE WAS
Suitability: Pre-teen/Teen
Character: Daniel/Danni

Set in the future, when climate change has impacted the world, Daniel/Danni is excited to find a leaf which he/she recognises from his/her dad's history book.

I can hardly believe it, am I seeing what I think I'm seeing? Jon look, it's a leaf. I saw one in a history book my dad had on the shelf in his office. Do you realise what this could mean? It's green Jon, it's not nothing, don't you understand? It was recently part of a plant! This is huge. They'll never believe us unless we take it with us. Put it in your backpack and let's make our way down the mountain. Ok maybe we should look for the plant first, you go that way Jon, I'll meet you back here at this rock. Don't be too long we must make our way back before dark.

My parents talked of a world with taste; I don't mean they had good taste in clothes, or music. I mean actual taste, one of those five senses that became four when climate change left us without crops, plants or any natural food stuff for that matter. I have grown up in a world without taste, with only bland manufactured consumables. I know nothing else, but I wish I'd experienced what my parents talk of. Maybe our discovery today will help us to revert back to that colourful world my parents refer to.

What was that? Jon are you okay? Where are you? Oh wow you're more than okay, it's amazing. It's better up close and in real life than in those pictures I've seen in my father's book. Quick let's make our way home, this is the beginning Jon, we can plant this and start to grow crops and maybe then we can finally taste all those flavours I've been dreaming about.

TURBULENT TIMES

Suitability: Pre-teen/Teen

Character: Lee/Leah

Lee/Leah has a fear of flying and is trying to avoid the family holiday.

So here we are, everyone looks so happy. My mum is already having a glass of wine and it's only 10am, and Dad thinks it's amusing to wear a sombrero for the journey. The journey... that's my issue. I wish I could feel excited, but I am so nervous. So here I am staring out of the window at the beast that I'll be boarding in less than an hour. When you're a kid you don't get a say in this kind of thing, it's assumed the whole family will be excited by the prospect of a holiday abroad. Well I'm not! And if another person tells me it's the safest way to travel, I will scream. Your words are no comfort to my overactive imagination which has already had me plummeting to my doom.

Oh no, was that announcement for us? I can't breathe, Mum I can't breathe. I'm not well, you guys go without me. I'll be fine; it turned out okay for Kevin in *Home Alone*. I don't want to go, I don't even like the sun. It will be too hot for me. Ok if you won't let me stay home alone then I'll stay with Grandma. Please don't make me. How does something that big and heavy stay in the sky?

My plea fell on deaf ears. So here I am strapping myself into this terrifying oversized tin can, pulling the strap

as tight as possible around my waist whilst still trying to breathe. Hold my hand Mum, tighter, suddenly I don't feel too old for hand holding. What was that? Should the engine be so loud? Okay I'm just going to close my eyes and pray. Whoa, take off. Feels like I'm on a ride at the fair, I don't like fairs either. I'm all for having two feet firmly on the ground. It's not natural to be in the sky. Then just like that the engine quietens, Mum, Dad the engine's not working! Panic setting in. Oh right I see, normal you say, okay well maybe I'll have a little peek out of the window. Oh my goodness is this window made of plastic? It's not natural to be amongst the clouds with only a sheet of Perspex separating us. Why has the seatbelt sign gone off? I'm not undoing mine. Breathe.

What's that down there? Wow! Look at the snow on the mountains. Suddenly as I start to calm there's a bump and the seatbelt sign is back on. What's that? Turbulence? What's turbulence? I can't breathe. Why would you put me through this Mum? And how is my dad sleeping through it? Just casually dozing under that stupid hat. I do trust you Mum, I'm just not sure if this is worth it for a sunbed and a swimming pool.

So here I am, chilling under a palm tree by the pool, shades on, mocktail in hand with my headphones in listening to some top tracks. Maybe the holiday wasn't such a bad idea after all.

MISSION COMPLETE
Suitability: Pre-teen/ Teen
Character: Johnny

Johnny is a gamer who is on a mission to prove to his mum that his choice of playtime is better than hers.

They're after me, don't turn around just keep going. Sharp left, sharp left! Slow down, okay take a sharp, sharp right and 3, 2, 1, jump. Luke you're supposed to be on my side, get the baddies, you're going to get us obliterated. Hi Jack101, join us, we need to get the crystal, Luke keeps forgetting whose side he's on. Right Jack, you take the lead and pick up any weapons you find on the way.

Yes Mum, I'll be down in a minute. I know I keep saying that, but my friends are on, we're playing. Please Mum, five more minutes. I just need time to defeat the Power Lord. I'll warm it up in the microwave. Okay, okay I'm coming. Sorry lads I've got to go, I'll be back on later, don't get us killed.

Mum do you have to be like that when I'm online with my friends? They can hear everything you say you know.

My mum didn't care what they heard though, she hated me gaming and tried her best to restrict my time on the games console. But the fact is, without it I'd be bored, and she knows it. She bangs on about what it was like in her day:

"We played outside from morning right through until our mothers called us in at night. We didn't have phones, or consoles or any gadgets."

So what did you have Mum? I asked more with a hint of sarcasm than any genuine interest.

"We had imagination, and a whole lot of fun," she said.

I wonder what sort of fun you can have outside with nothing to play with but your imagination. I figured the seventies was a strange old time. It all sounded pretty boring to me. But I was ready to prove a point to my mum, so I called her bluff.

I'm just going out for a bit Mum, I'll be back in a few hours or when boredom takes over. She asked me where I was going, to play I replied, without gadgets, you know in the fresh air with my imagination. I won't take my phone out with me because that might stunt my creativity when playing my new imagination-fuelled games. I'll just leave it on the side here. Like you've said before it's just as safe now as it was back then, it's just that missing kids are reported more, and *you* didn't need a phone for emergencies so I'm sure I'll be fine. Besides, if needs be, I'm a fast runner. I'll see if Luke and Jack want to try this new playing out thing, I'll go and... what did you say it was? Ah yes, I'll go and *call* for my friends and see if they want to play out. Bye then. As I turned to walk away, she shouted, "Wait!" Yes Mum, am I forgetting something? Ah you're having second thoughts, aren't you? It is getting

a bit dark, but that didn't bother you in the seventies did it? So off I go, no need to worry. Unless, well, if you'd rather I went online, I can play with my friends there and you know you can keep an eye on me.

"You're forgetting your coat son," she said.

Oh I didn't see that coming, ah it's a double bluff, I see what she's doing here. Bye then, I'm opening the door now and leaving the house, in my warm winter coat but with no phone for emergencies. I shut the door behind me and start to walk to the end of the drive, twelve steps in Mum opens the door. "Fine," she said, and gave me twenty more minutes gaming before it has to be switched off. Deal.

Hey guys, this is Johnny reporting back. Sorry it took so long, there was more than one operation I needed to complete today. Let's just say mission accomplished.

EXCITEMENT IS EXHAUSTING!
Suitability: Pre-teen/Teen
Character: Amy

Amy's mum treats her to an evening at the theatre watching a ballet. Although Amy loves to dance, she isn't so keen to watch it and finds it hard to appear interested.

Do I look excited? *(To member of the audience:)* Sir it was a rhetorical question!

Do I? Of course I don't, because I'm not. 'It will be the most exciting day of your life so far,' my mum announced. Interesting she put so far on the end of that sentence; even she didn't think it would be the most exciting day of my life ever. You see, I loved going to my dance classes every Saturday morning, I loved wearing the pink leotard and tights and my precious ballet shoes, the feeling I got when I danced around the studio was like no other. So I guess I could understand why my mum thought a trip to the theatre to watch a ballet would be the perfect gift for my birthday. 'Thanks Mum,' I said, feigning excitement, but inside I was simply disappointed. You see I love to dance, but my idea of fun isn't watching others do the same; quite frankly watching others do ballet is boring. But my Mum thought she had come up with the best present idea ever and I didn't want to upset her, so I smiled and faked enthusiasm for the idea.

And so here we are the night of my birthday treat, Mum spent hours getting ready and she refused to let me wear my jeans, so to add to my misery I had to wear a dress. We enter the theatre, it's old but my mum calls it ornate, whatever that means. We take our seats on the front row, yep the front row! More fake excitement required. Even the dancers would be able to see my bored expression. The music starts and Mum glances at me with a huge smile on her face, I smile back and try hard to keep that smile painted across my face, but I'm not too good at that. The accompaniment is so slow and it's making my eye lids feel heavy, oh no sleepiness has kicked in and I can't fight it! Another smile at Mum to reassure her and now I'm going to just rest my head on my arm, get myself comfy. Suddenly I hear Mum say, 'Wow! That was just wonderful wasn't it darling?' 'Sure was!' I try to wake myself up. Would I like an ice cream? Ice cream? I thought we would be going home. 'Erm no thanks Mum.' It's the what? The interval? And then it dawns on me, there is more to come, we are only halfway through! Faking excitement is exhausting!

ONE LAST SPELL
Suitability: Pre-teen/Teen
Character: Silvia

Silvia tried to persuade Cinderella's fairy godmother to cast one final spell to help her get a boyfriend.

So you're my fairy godmother? You're not what I expected. I thought you would have a wand at least, and maybe a bit of bling. You look pretty ordinary to me, no offence. Well it's nice to meet you finally, my name's Silvy, short for Silvia. I've heard lots about you and the amazing things you can do with a pumpkin. Anyway, I was wondering if you could sort me out with a prince? Rumour has it you've got a good reputation and a successful record of providing ordinary girls like me with handsome guys. That Cinderella girl who lives in the royal castle started out like me, right? And it's all worked out for her, happily married and living a life of luxury. Anyway, Fairy Godmother, can I call you FG? I've taken it upon myself to collect a few things in preparation, so here's an oversized item of fruit, you have no idea how hard this was to find. And in this cage are a couple of mice, they're my sister's pets, Mork and Mindy, but I don't think she'll miss them. What else do I need? If I'm honest I'm not too fussed about a carriage, that's a bit old fashioned, or glass slippers, they just sound rather fragile and a little dangerous to walk in. I'm just after a bit of a make-over and an opportunity to bag myself a rich guy. I can just picture myself now in

the royal suite, wearing my very royal and ultra-sparkly gown with my feet up on a beautiful chaise lounge, being waited on hand and foot. Whilst my stylist and beautician work their magic. Can't you just picture the scene FG? There would be wannabes crowding at the castle gates to catch a glimpse of my super handsome prince, but he would simply tell them to leave, as he already has the most beautiful wife in the land. What do you mean who? Me of course. What do you say FG? Sorry what was that? Really? But I've collected these things so if you could just nip home and get your wand, I'm sure one last spell wouldn't hurt. Oh ok, so I can't persuade you to come out of retirement?

The following two monologues are inspired by the play *A Striking Friendship*.

A STRIKING FRIENDSHIP
Suitability: Pre-teen/Teen
Character: Alison Samson

Kevin asks Alison on a date. She is suspicious of how he can afford it and it soon comes to light that his father has crossed the picket line.

The cinema? What you want to take me on a date or something? Well I do like Harrison Ford, so maybe... no I can't. Look no offence Kevin but we haven't got any money. You'll pay? But your family are skint too. Maybe we can just go to the park, listen to your Walkman or something. Oh no, here we go, avoid eye contact, it's the BMX bandits. Kev, don't say a word, let me handle it.

Hey you, don't call him that! Get lost, why do you always pick on him? He's never done anything to you. Go on, do one! Go and push around someone your own size. Are you ok Kev? Don't turn on me, I wasn't trying to save you, I *did* save you. They'd have kicked your head in Kevin if it wasn't for me, they're thugs. What did they mean when they called you Scabatha? It can't have been nothing, they seemed pretty angry with you. You can tell me anything Kev, we are supposed to be best mates. Your dad has what? But he can't, that's crossing a picket line Kevin, don't you realise what that means? So that's why you could afford to take me to the cinema. Well I won't go, I don't care if

they're showing the entire Star Wars trilogy back to back, my parents will lose the plot when they find out. I won't use money from a scab! And neither should you. I'm sorry that your mum is ill and I get that your dad thinks the money will help her, but this is about more than just your family. Don't you get that? Kevin I'm sorry, but I can't see you anymore. It's not just going to be the issues between our parents, it will be the whole community. You can kiss goodbye to life as you know it. I'm sorry, see ya Kev.

HARD TIMES

Suitability: Pre-teen/Teen

Character: Alison Samson

Alison talks about her family in light of the 1984 miners' strike.

It was just the way things were, but it was tough, tough times for everyone. My mum didn't realise it but really she was the strength behind it all, she was the rock holding up our family. My mum worked hard every day of her life keeping us all happy, organised, fed and watered. After all it was the eighties and it wasn't uncommon for wives to stay at home. Dad went out to work and Mum didn't. I loved coming home from school to her home cooking, she made a mean lasagne and we had that every Friday like clockwork. Life was good, well for a while anyway. Mum was a Queen fan, she adored Freddie Mercury, she said his moustache made him look sophisticated, she said he was the only man she would leave Dad for. Not sure he'd be interested!

My dad is a strong man in many ways, he works hard and has strong values. He takes life seriously, and what he believes, he believes, and no amount of debate or discussion will change his mind on any topic. But most of all political issues which us kids just find boring. There is no doubt in my mind that he was no fan of Thatcher and he expected us all to follow suit. Which wasn't too difficult while living in a Yorkshire mining village in the eighties.

My dad had worked down the mines all his life, it's all he knew, and now we had nothing, and I mean nothing. We literally did not have a thing.

My brother Stuart thought the world had ended when Mum took his personal stereo to the pawn shop, he's going through a selfish phase, Mum calls it puberty. Shelley my older sister spends all day everyday practising routines to her favourite Wham songs, and learning the lyrics by rewinding the cassette tape over and over again. It can get really annoying, basically her life consists of Smash Hits magazine, spiral perms and boys. I'm not quite sure where I fit in. I'm not like any of them. I just spend my days hanging out with Kevin, or at least I did. He's my best mate, or should I say was, until my dad put a stop to that. Apparently his dad's a scab and because he went back to work and crossed the picket line, Kevin and I aren't allowed to see each other anymore. I'm supposed to blame one person for everything including my lack of friends, lack of food, the missing TV and the general misery in this community, and there's no surprises for guessing who that is. Thanks a lot Maggie!

BITTER SWEET NIGHTMARES

Suitability: Pre-teen/Teen

Character: Gretel

(Gretel and Hansel could be the other way around if played
by a boy, by changing brother to sister, he to she, etc.)

*Gretel's brother Hansel has been missing since he was coaxed to the
witch's cottage. She is suffering from nightmares and guilt that she
ran away and left Hansel behind that fateful day and talks to her
therapist.*

I just want them to stop. I haven't had a good night's
sleep since it happened. What if they never find him?
My brother was a little stupid, but he doesn't deserve this.
He's been missing a year now and it's getting harder not
easier. I saw her with my own eyes, his abductor. She was
pure evil, even to look at! She had bright green eyes and
skin to match. Her voice cackled like a witch, and I know
she had plans for both of us that day. She had carefully
coaxed us to that cottage. I know what people are saying,
they say it was his greed that led to this. He may have
been tempted by the sweets, but he didn't deserve to be
held captive. You think I'm making this up, don't you?
It's not my fault the cottage isn't there anymore. It was
made of confectionary, a temporary construction to lure
children in, and it worked. But I can promise you, it did
exist, and everything I'm telling you is absolutely true.
Poor Hansel, I shouldn't have run away, I should've stayed
and tried to help him. But she grabbed him so hard and

wouldn't let him go. I got scared and my brother yelled, "Run Gretel, run." So I did, and now I'm plagued with these awful nightmares where she is putting my brother into an oven, and I'm running towards him, screaming, but my legs are heavy like lead and no sound is leaving my mouth. You call it survivor's guilt but that insinuates Hansel is dead, and you don't know that. I'm going to lead a search myself. She was so wicked; I know she will do the same again to other children. All I need to find is a trail of sweets to lead me straight to her.

I'M NOT SCARED
Suitability: Pre-teen/Teen
Character: Oliver

Oliver wants to watch a horror film even though the film is too old for him. He finally steals the moment to watch one but soon realises ratings are there for a reason.

Please Mum, please! Just let me watch it, my friends are allowed.

'Oliver, I don't want to have this conversation with you again,' she says, as per usual.

All I want to do is watch one horror film, but my mum is so over-protective; she lets my sister watch some horror films and the ones she's not allowed to watch she watches at her friend house, and she doesn't get told off for it. If I did that, my mum would probably throw my DVD player out of the window. One day we were in a deep conversation about it and my mum was saying something about how I shouldn't watch a scary movie because I was too young, and it would scar me for life. I wasn't really listening to be honest but eventually she stopped talking, and I nagged and nagged and nagged and nagged until finally she said, 'I'm sick of hearing about it, just go and ask your dad.' It was the best thing I could've hoped for. The thing with my dad is that if I asked him, he would say go and ask your mum, and it would end up being a big fat 'no' again, so I had to go for a tactical approach. I waited

until one night after he had been out to the pub with his friends for a drink, and he was all tired and a bit drunk and he had flopped onto the sofa, and I asked him… Can I watch a Wes Craven film? 'Whatever,' he responded in a kind of slur.

So here we are, my mum is just leaving for work, and here we go.

Oliver clicks a button on the TV remote, we hear various gasps and his facial expressions gradually show increased fear.

I can't watch any more. I told my mum I could stay at home by myself for a whole hour, I hope she's back soon. I think I'll just watch for her coming back…

He hides behind the sofa.

…From behind the sofa.

Written by Evan Watkinson
Edited by Joanne Watkinson

THE AUDITION

Suitability: Teen

Character: Sally

Sally attends an audition, she is nervous as she doesn't feel like she stands out like all the other girls.

I can feel my heart beating faster, sometimes I wonder why I put myself through it. I've had thirty-two auditions in total and only one recall, but something tells me this will be the big one. What is she looking at? Can she tell my legs have gone to jelly? Maybe she's trying to psych me out, well that's good, she must see me as a threat. No, don't be ridiculous Sally! You're overthinking things again. Okay Sally Ann, and breathe. *(She takes a series of deep breaths.)*

This is the worst bit, the wait, the looks, the game faces. You always get the pretentious ones: "This is my third audition this week, the last director I worked with said I had something special." Blah, blah, I can see two things he thought were special about her! But me, well I know I'm pretty... pretty plain that is. I don't stand out in any crowd, why would I stand out here with all these beautiful, experienced girls? I know I should probably give up the dream, but I just can't seem to let go of what I've always wanted. Sally isn't even a stand-out name. You see her there, the one with the blonde hair and perfect teeth, yes that one, well her name is Bluebell Constantine Viola. Yep, real name apparently, and the perfectly groomed

brunette in the corner, her name is Lightning Storm. So you see, 'Sally Ann' doesn't really make me unforgettable. It's not about pure talent these days is it? It's about who you know, what you know and what daft hippy name your parents gave you. Nothing against hippies of course, I'm all for peace, love and all that, but sometimes I think parents must've planned ahead. Planned their newborn's path to stardom, starting with a quirky name that's totally unforgettable. Listen to me rabbiting on, it's just my nerves, I'm so rude, I haven't even asked your name... Tinkerbell...as in Tinkerbell and Peter Pan? *(Awkwardly:)* Aww what a beautiful name. Well Tink, do you mind if I call you that? Oh okay, Tinkerbell it is then! It's been nice talking to you, but I think I heard someone call my name, my exceedingly boring name. Break a leg!

CYBER TORTURE
Suitability: Teen
Character: Jemma

Jemma is struggling to deal with bullies at school.

There's nothing wrong Mum, why don't you believe me? I am happy; yes, school was fine, everything is just fine. I don't need to talk and I don't need a cup of tea! Back off, I've got homework to do. I don't lock myself away, why would you say that? I just like hanging out in my room, that's all. I need space Mum, I'm not a little girl anymore, chocolate can't fix things. That's not what I meant, nothing needs fixing, it was hypothetical! Please just leave me alone.

How dare you, how dare you stand there and call me names, oh wait, you don't say those vile words to my face do you? Because you are a coward, you hide behind your laptop spending endless hours entertaining yourself, creating new ways to hurt me, and encouraging other weak-minded people to join you! You have nothing else to fill your time with because no one really cares about you, that's the truth! You hurt me to mask your pain. Well I feel sorry for you, but it stops now. So take yourself off to your gang of nasty little creatures and get yourselves a life. A real life, in real time!

That's what I want to say to her, but I don't, I can't. I feel incapacitated when I'm around her and her flock

of pathetic little sheep. I'm angry inside but I can't let it out. I just seem to take my anger out on my family; I haven't found a way to confide in anybody about what is happening to me, I feel too humiliated. I don't know how much more I can take, the torture is relentless. I am ignored at school and tormented at home. I know I shouldn't look at the comments, but I can't seem to help it. The only way would be to not have a phone or laptop, but I can't, my mum would wonder why I'm not answering to her calls and I really don't want to worry her by telling her of my pain. There is this teacher at school who is kind and although I think she probably just feels pity for me, she's the only one I could possibly talk to. I'm just scared in case it makes things worse. I've had a rucksack packed for several weeks now, it's hidden under my bed, I keep it there next to a rope, because I know there are only two real options for me, to run away or leave this world for good.

DEAR JENNY
Suitability: Teen
Character: Ellie

Ellie returns from school one day to face her distraught mother sobbing over her husband's infidelity.

I was walking home from school just chatting and laughing with my mates when a strange feeling came over me. 'Nothing's wrong,' I kept saying to my best mate Suzy, but a chill went down my spine. I picked up the pace – 'I need to get home Suzanne.' She looked at me, confused, and I began to run.

I found my mum sobbing in the kitchen on the floor. I thought we had been burgled; every single piece of crockery was smashed. Then I saw the letter on the side, it was addressed to my mum, from my dad.

Dear Jenny,

I'm sorry it's come to this. I've tried to hide my feelings, but I can't live a lie any longer.

I didn't need to read anymore, I knew, I'd been expecting it. It happened last New Year's Eve, we always went around to my Aunty Shell's house for a family party. The adults always got a bit tipsy and Dad would always let me have a small glass of bubbly at midnight, I didn't really like it, but it made me feel grown up. We stayed later than usual this year as mum had had one too many and fallen

asleep on the sofa. All us kids were playing on my cousins' X-box, I decided to go outside and get some air and as I opened the back door, I saw them, kissing. It was dad and Auntie Shell. My heart sank. They didn't see me, and I just pushed it to the back of my mind, pretending it hadn't happened.

'Tell Ellie I'm sorry,' the letter said. 'Don't cry Mum.' She held me tight and I held her tight right back. She was so sad, and in that moment I hated him, and Aunty Shell. My own mother's sister. I will never understand adults, they spend their time telling children how to behave but they don't know how to treat each other. It's complicated they tell me, you know, being an adult. Well it seems perfectly simple to me, be nice, that's it really, love your family and don't destroy them with your selfish actions. My mum needed me more than my dad so if we're taking sides, I know which one I'm on. 'Sorry Ellie' just isn't quite enough.

MORE DRAGONS

Suitability: Teen

Character: Robert

Robert has moved schools and Tom has been the kid designated to look after the new boy and give him a tour of the school.

So Mr Hill chose you to show me around. That's great, just great. I'm really glad to be here. Nice to meet you Thomas, Tom. No, not really. I went to the best school London has to offer. My chance of a promising high-flying career was, well, quite frankly off the scale. It was inevitable that one day I would follow in my father's footsteps. It's very unlikely that I will achieve the same grades here. So this is the English block, the library is a little bleak. My dad's an author; he's won awards and everything. That's how he made his millions. He hasn't written anything you'll have heard of, they're to do with neuroscience and astro-physiology. You know, clever stuff. I haven't only read them Thomas, I contributed to the research. Yes it's true, I'm a member of Mensa, it's a society for geniuses. No Tom, astro-physiology isn't just to do with star signs. Whatever, where's the sports hall? I was in my school's football team, top scorer in every match. My dad knows David Beckham, I went to school with his son. Yes of course we were friends, I have lots of friends, I'm sure they're really missing me. Is this the languages classroom? I'm multilingual, I can speak five languages fluently. Probably because I've travelled the world with my

dad, he's like a travel correspondent for the BBC, between writing top books on super intelligent stuff. He writes as we travel from country to country. You're right, he's very busy, He's working in London though at the moment, giving the Prime Minister advice. Advice on everything he needs advice on, which is quite a lot. He knows everything about everything, my dad. You know, all the super clever important stuff anyway. This music room is a bit limited in resources, don't you think? Yes of course I play an instrument, several actually. I've been learning piano since I was two, guitar since I was three and drums since I was four. I'm basically a one-man band. My dad was the sixth Beatle you know, oh yes there were six actually. It was short-lived though, too much talent in my family, makes others feel bad, so he quit. My musical talents tend to draw in the girls too. Have you got a girlfriend? Oh don't worry, you will eventually, the girls from home won't leave me alone; I get messages all the time. They go crazy for a musician. Well they're not girlfriends as such, more fans really. Can you show me the restaurant? Oh okay, cafeteria, at my old school it was known as a restaurant, we had top chefs and everything. Yes we are pretty rich, no coming here is just an experiment. Yes. Why else would I be here? I'm seeing how the other half live. I know what your suspicious mind is thinking, my parents are still together you know, they haven't separated, my dad didn't have an affair with his personal assistant, we haven't had to sell our mansion, we still have a big house in London with a Jacuzzi and cinema

room, I still get fan mail from local girls, my thousands of friends are lost without me, I'm still officially registered in the top school in the country, which I will return to after the experiment is over, and my dad is still a travelling author who advises the Prime Minister and socialises with the Beckhams. Wait Tom come back, I'm not a liar, I'm not. What do you mean my story needs more dragons? I'm not exaggerating. It's all true. It really is. Thomas come back, Mr Hill said you have to be my friend.

DEAR DIARY
Suitability: Teen
Character: Gail

Gail confides in her diary about the troubles she's having at school.

Why do they look at me that way? Don't they know how much it hurts? How lonely I am? How much I wish I had just one person I could talk to? I walked to school alone as usual today and that was ok, until those nasty girls began walking faster behind me, step by step, catching me up. My heart started to beat faster and faster, I could hear what they were saying about me. They were talking just loud enough for me to hear, they wanted me to feel the pain of their words, all those nasty names they were calling me stabbing me straight through the heart. I picked up the pace and hoped the road ahead would be quiet so that I didn't have to stop and wait for the traffic. Fortunately it was clear, I could hear their footsteps right behind me as they caught me up, but I didn't turn around, I didn't want to provoke them. I felt a single tear run down my face, proving that I was weak just like they said I was, I was pathetic and once again I was alone.

I reached the safety of my classroom, where I was surrounded by twenty-nine other thirteen-year-olds, none of whom had ever said one kind word to me. I occasionally got a sympathetic smile from Josey Monroe, she had dealt with similar things in primary school, but even she didn't

want to be my friend. I guess she fears being back where she was a year ago, she fears walking each day in my shoes. I just fear being.

Diary, you are my only friend.

KARMA

Suitability: Teen
Character: Ava

Ava blames herself for the unexplained disappearance of one of her peers.

It's hard trying to maintain normality. She has been missing more than two years now. Everyone else seems to be moving on with their lives, but I can't. I can't stop thinking about her. You see, it's my fault. I made life unbearable for her and now it's unbearable for me. What do they say? Karma, that's it. I'm experiencing Karma.

She was new to my school, a pretty girl but quiet. It was a Tuesday when she arrived, Miss Hilton brought her into the classroom, she had her head down and looked awkward. Miss forced her to say hello and we all responded. I hoped I wouldn't get chosen to look after her, my life was uncomplicated at school and I didn't want her to infiltrate my social circle. I had finally been accepted into the "in crowd" and having her tag along would be social suicide.

Miss Hilton didn't pick me that day, she picked my new best friend, my very popular best friend Charlotte, more commonly known as Charlie. I didn't feel threatened at the time, this new face wouldn't fit in with Charlie's group. But gradually as the day went on, I could see their relationship building, they were laughing and joking in the

lunch queue and Charlie didn't save me a place. Was this really happening?

So I did the unspeakable, I caused Lily Mae Whitfield unbearable torment. Starting the very next day. I spread rumours at school and trolled her on social media. How could I have been so jealous? So malicious? So insecure? The irony of it all was that really, Charlotte Grainger was never my friend, our relationship was as fake as fake can be. For some reason her approval meant something then, it made me feel relevant – short-lived relevance.

So here I am, sat outside the head's office, because the police officer in charge of Lily's case wants to speak to me about her disappearance. She wants me to help with enquiries.

She takes a seat in the head's office.

I don't know where she is. In fact, I don't know much about her at all. If you're here to arrest me, please get it over with. I am a despicable person, I made Lily's life hell. I'm not surprised she ran away.

She's what? She can't be. She can't be dead. I didn't mean it, was it because of me? She wouldn't take her own life because of silly comments, would she?

INNER BEAUTY

Suitability: Teen

Character: Lynne

Lynne likes her own company, she never draws attention to herself, unlike Sally Daniels, who decided one day to pick on Lynne and steal her anonymity.

Can you be beautiful yet ugly at the same time? The answer is yes, and I know this to be true. She has the longest blonde hair and the brightest blue eyes, her skin is perfect and I spend most days staring in her direction, wishing I could be more like her. But last Monday after school I saw an ugliness that no physical perfection can disguise. It was on the school bus; I normally walk, but for some reason I decided to take a ride home instead. I was minding my own business, reading my book quietly, when she sat next to me. She's never even acknowledged me before and to be fair she didn't speak to me then, either, at least not at first. I was invisible to her, to most people if I'm honest, but I like it that way. I've always been comfortable with my own company, I guess it's just easier. I liked that no one knew my name, that I was anonymous. But it's fair to say I've always admired Sally Daniels, she was a social butterfly who everyone seemed to like, she was kind of glamorous like the stars on TV. The boys fancied her and the girls wanted to be her. Anyway, that day on the bus, her phone rang. "I'm on my way, give me a break!" That was Sally's frustrated response to whoever was on the other end of

the phone. She seemed to morph into someone else at that moment, she was muttering to herself angrily. I felt uncomfortable, she must've sensed this, and she turned to me, "What are you looking at minger?" Minger! What a vile word, it's true I'm not your magazine-beautiful picture-perfect kind of girl, probably a little ordinary, but to be called a minger was unfair. The bus pulled up at my stop, "Excuse me Sally," she laughed, I mean really laughed in my face. "You want to get past minger?" And with that she pushed me; as I fell, I heard the raucous laugh of the entire bus and suddenly in that moment I was no longer invisible. Do you know what? That experience on that Monday afternoon made me realise invisibility is a gift; Sally wasn't beautiful, she was ugly, and her ugliness stole my anonymity. Life hasn't quite been the same since. Kids see me, but for all the wrong reasons. They laugh at me, call me names and taunt me over my looks. But I know that if I chose to, I could put make up-on to make myself pretty. Sally Daniels has an inner ugliness that no amount of cosmetics can cure.

CHAPPED
Suitability: Teen
Character: Mary

Mary is homeless and desperate for a night of shelter, whatever the method. She goes shoplifting in the hope of spending the night in a prison cell.

It wasn't a lipstick, it was just a lip balm. Okay I know it's still wrong, but my lips are, you know, all cracked; it's cold out there. I'm not trying to get your sympathy, people like you don't feel anything. Every case is the same to you, doesn't really matter *why* I took the lip balm. Let's face it, if I wanted to make my fortune, I wouldn't have taken moisturiser for lips now would I? I'm not being cheeky, just factual. Look it's just real cold this time of year and my lips get sore. You think that's the answer? Well I can't Sherlock, I can't go home, I just can't okay. I'm not getting testy, I just, just can't go home, that's all. You can't call them. No not social services, please. Just don't. Listen Mr Hotshot Security Guard, I can't go home because I don't have a home to go to. You'd never make a detective. Ok sorry, so that *was* a bit cheeky, but come on dude, take a good look at me. Do you recognise me at all? I guess not. You walk past me every day on the way to this poxy job, whistling an annoying TV theme tune, while you stuff your face with a doughnut and wash it down with a chocolate smoothie. You pass me at the same time every day and every day you avert your eyes so that you don't have to

acknowledge me. Don't worry, I get it, it's awkward to look someone in the eye that you don't want to help, that you have no respect for. That you consider a complete waste of space. I know you think people like me dirty your streets, that we are all bad to the core. That if we beg for money it's for drugs not food. Hey look, go ahead, arrest me. You want to know why I'm really here, sat before you, having this moment of shame? It's because I chose to be here. You're right about one thing, it didn't really matter if I took a Chapstick, a lipstick or a flaming chop stick! It wasn't about *what* I took, it was about *why* I took it. One thing is true, it's cold out there, my lips are chapped, I'm tired, and I just want one night of shelter, just one. So go ahead arrest me, lock me up for the night. That's what I came for, I let you catch me. I can shoplift without getting caught you know, it's not that hard. But we both win here, I get a night in the security of a cell and you get brownie points for catching me. But next time you walk past me, remember that the girl who took the lip balm just wanted eye contact, acknowledgement of her existence and one night of shelter.

I'M NOT A VANDAL

This monologue is from the ensemble play **Intrusion**,
which explores mental health issues, in particular OCD
and intrusive thoughts.

Suitability: Teen
Character: Susan

Susan is working through some deep-seated issues with her therapist.

Susan rips a page from a book.

Is this vandalism? That's what my teacher called it and I
enjoyed a week's worth of exclusion for my actions. I didn't
do it in a reckless way, I just had to. The staff at Elmhurst
School think I have anger issues. They think I'm always
battling against them. I am in a lifelong battle, but not
with my teachers or my family. My battle is internal. My
battle is with my mind. There are several page numbers
that don't sit well with me, not just page numbers actually,
numbers in general. My therapist explains it as a safety
buffer I've created for myself, to protect me from what I
perceive as bad things in life. I can't say the feared numbers
out loud, which is why I can't tell you what they are right
now, and I can't look at them on the page, but let's just
say they cause me a great deal of anguish every day. In
Maths at school I would rather get a question wrong than
write one of these numbers down. I'm brighter than my
teacher thinks.

I loved stories when I was little and each night at bedtime
my mother would tuck me in and read to me until I fell

asleep. Now to most children this would be a source of comfort, but for me it was an anxious time of day. I couldn't tell my mum how I felt, she would think I was weird, so when she turned the fateful page, I closed my eyes tight and held my breath. I favoured short picture books for this reason.

Sometimes it's hard to imagine what normal might feel like. I want to know, I really do, which is why my therapist Doctor Imhan has suggested I keep a video diary and follow some challenges, so we can watch back and look at ways of unpicking my behaviours. I'm pretty sure I'm her guinea pig, let's save the poor little weird kid.

Numbers have dominated my whole childhood so far: I count my steps, I can only do chores in even numbers, and I even brush my hair with a certain number of strokes each morning. The rituals are demanding and encapsulate my whole existence, but I feel like they keep me safe. However, I think I'm ready to change. So here I am, video diary number one and Doctor Imhan's first challenge. Read the first paragraph of the page between five and seven.

Deep breathing.

Susan you can do this, I'm turning page five.

She shuts the book.

I can't.

More deep breathing.

One more try, page four, page five.

She rips out page six and throws it to the floor, she is rather distressed and kneels next to the crumpled paper. After some time, she carefully and slowly unravels it, and begins to read, taking calming breaths as she does.

"The forest was dark and the little girl in the red cape was beginning to feel uneasy. She no longer recognised the path to Grandma's house despite having taken it so many times before."

I'm not a vandal, I'm not weird, my name is Susan and I have numerophobia coupled with the ritualistic behaviours of OCD, and I have just completed challenge number one.

UNDERWORLD

Suitability: Teen

Character: Persephone

Based on the Greek myth, Persephone is kidnapped by Hades, the God of the Underworld.

What beautiful flowers and the perfect day for picking them. I shall collect them in my basket and take them home to mother. Wait, what was that? The ground beneath my feet shuddered. Oh my, there's a crack appearing, what is happening? Where is the light going? It's so dark. I must hide at once.

She crouches beneath a rock.

Who are you? Hades? You mean the God of the Underworld? The one who wished to marry me! My father has made his wishes very clear, so what are you doing here? But I don't want to go with you, I won't. Get off of me, get your hands off of me. My father will not allow this, he is Zeus, God of the sky and thunder and supreme King of all Gods, and he is more powerful than you.

It's dark down here, what pleasure do you get from forcing me to stay. You cannot force me to love you. I don't want to be the Goddess of the Underworld. My father will come looking for me, you won't get away with this. I am not naïve! He's what? Your brother? My mother will not allow this, she will find me. I will not be queen to anyone,

least of all the dead. This place gives me the creeps. Pomegranate seeds? You think that makes things better, do you really think you can entice me with fruit? I don't want your pomegranate seeds.

She tastes them.

Although they do taste rather… No! I know what you're doing and you will not lead me into temptation. They may be sweet – unlike you, you monster! – but you cannot make me stay. Let me out! I am not your wife, I am Persephone, daughter of Zeus and Demeter, and my mother has always protected me from men like you. She will find me, she will.

MIRROR, MIRROR
Suitability: Teen
Character: Jane

Jane is unhappy with her plain look and decides to experiment with make-up for the first time.

Mirror, mirror on the wall who is the...? Blah, blah. Like I'm going to get an answer. Well if by fairest it means prettiest then it's going to be Melanie Stephenson, everybody loves her, the boys follow her around like lost puppies and the girls just simply want to be her. I don't even like looking at you, mirror. It's a necessity for me, so that I don't leave the house looking like a scarecrow, at least that's what Mum says. She just doesn't get the whole make-up thing. 'Why do we need to paint our faces? Surely that indicates we aren't happy with what's underneath.' It's always baffled me too if I'm honest. Melanie always has bright red lips and long eye lashes, which she covers in mascara and reapplies every break time. My mum always said, 'You're beautiful just as you are, Jane.' Well the mirror just isn't backing you up on this one Mum. She has never allowed me to wear make-up; even when dressing up as a child, she wouldn't let me try on her heels or her dresses. I guess that has stuck with me. I'm not very fashionable and I wouldn't even know where to start if I went clothes shopping. My mum still dresses me like she did when I was eight, but I'm a teenager now and the kids at school tease me for the way I look.

Mirror, I think I need a makeover, I'm sick of being plain. I'll never understand why girls think they need make-up, and I've always prided myself on my individuality, but it's not really my individuality is it? It's Mum's. But now I just want to fit in, so mirror, I've used my pocket money to buy this make-up kit, here goes. Oh gosh my hands are a little shaky. Okay, a bit of lippy, that's what Melanie calls it. Some blusher to make my cheeks rosy – I've never understood why anyone would want to look permanently embarrassed, but here goes – and some eyeshadow, which apparently widens the eyes, can't honestly see how that's scientifically possible. There, how do I look? Do you think I'm fit for the red carpet? And the award for make-up artist of the year goes to Jane Smith. Thank you for this, my first Academy Award, I would like to thank Melanie Stephenson for inspiring me and all the superstars I've been so honoured to work with. Thank you, thank you all.

Oh no! Yes Mum I'm coming, oh goodness me where are those wipes? Quick Jane, remove, remove. Coming Mum, I'll be down in a second, I'm just erm, freshening up! Freshening up? Who says that these days? Jane, it's a lot less stressful being plain.

Mirror, mirror on the wall, who's the plainest of them all? That would be me.

LESS IS MORE
Suitability: Teen
Character: Skye

Skye is an ordinary teenager dealing with her Mum's fear about her growing up and the possibilities of boyfriends on the horizon.

Sometimes less is more. My mum says this on a regular basis, usually when I'm getting ready to go out and usually in reference to my make-up. The only time this phrase didn't work for her was when I went through my miniskirt phase. I think she would like me to be a Plain Jane, anything to keep the boys away. I keep reminding her that I'm a teenager now and I'm not a baby anymore, she'd have me in a pinafore dress, woolly tights and T-bar patent leather shoes for the rest of my life if she could. I get that she worries, but making myself feel good with a bit of make-up and a nice off the shoulder top isn't like a peacock attracting its mate. I do it for me, so *I* feel good, not for the boys. I'm not even interested in finding a boyfriend. My best friend Jenna had a boyfriend once and he just got in the way to be honest, she stopped hanging out with me and everything she did seemed to revolve around Andy Rolfe. I got sick of hearing his name. It was short-lived though, and we get to go out together again now, but it's convinced me it's definitely mates before dates for me. The irony in my mum's favourite phrase is that I've seen photos from her school days in the eighties, and there was nothing that said less is more about those

pics. Maybe she needs to remember what it was like to be a teenager, and be grateful I'm not sporting fluorescent odd socks, a fishnet top and a seriously iffy perm! I mean seriously, in those days their hair made their heads look three times the size. My dad was no better, he wore all black and these really pointy shoes, apparently they were called winkle pickers. They looked pretty stupid. But the thing I notice most when I look at their grainy old photos is that Mum had make-up that thick, it could only have been applied with a trowel. Her mascara was so heavy it almost made her eyelids droop, and just for the record, electric blue was never a good look. So next time she says, 'Skye, remember, less is more,' I'll reply with, 'Mum, remember the Eighties?' Case closed.

THE UGLY VASE
Suitability: Teen
Character: Emma

Emma is faced with a dilemma when the vase that her gran's ashes are kept in is featured on the Antiques Roadshow.

Now let's get one thing straight, I loved my gran more than you can imagine. She looked after me every weekend when my mum had to work, and we were close. So when she passed away I found it difficult to accept, we all did. My gran had a favourite vase in her house, which was always filled with flowers from her garden. It was rather old fashioned and if I'm honest a bit ugly, but she loved it, and it took pride of place on her glass cabinet. My grandfather – who I never met, as he died before I was born – had given it to her on their first anniversary. So to her it was sentimental, to me it was a bit of an eyesore, but seeing it sat there and thinking about Gran and her love for life made me smile.

My mum had this bright idea after Gran passed, to put her ashes in the vase and place her on the mantel piece. Now I'm not going to lie to you, I find this spooky rather than comforting, but it makes Mum happy. So she's been sat above our fireplace, watching us, for two years now, and here's where my dilemma begins. A month or so after Gran's passing, her will was read, and guess what she left me? Yes, the totally unattractive, slightly garish, yet

unequivocally sentimental vase. Which unbeknown to her was now her final resting place. Doesn't sound much like a dilemma does it? Except last night I was watching the Antiques Roadshow, you know the one where old people bring in ancient stuff and the experts comment on its beauty, even when it hasn't got any, and they tell you it's not worth as much as you'd hoped. I love watching their fake smiles as they try to cover their disappointment in their precious item's value and pretend it would mean too much for them to sell it anyway. Suddenly it caught my eye, when I say 'it' I mean the vase, Gran's vase, well one just like it anyway. I turned up the volume. Oh jeez, did I hear that right? Mum! Mum get down here, you'll never believe it. It's Gran, I mean well not actually Gran but her vase, it's on the tele. Mum didn't hear me so I quickly pressed record. What if it's worth millions? Flashes of my new lifestyle passed through my mind. Think of the holidays, the clothes, the new house. I imagined new resting places we could find for Gran, maybe she would like to be sprinkled amongst the trees, but she wasn't really an outdoors kind of person, or maybe we can get a little headstone and sprinkle her around it. No wait... I glanced at the vase on the mantel, guilt consumed me. I turned off the TV, I didn't need to know how much it was worth. That ugly, unsightly vase was quite simply priceless to me.

CURTAIN GOING UP!

From the play **It Started with a Kidnap.**

Suitability: Teen

Character: Annabelle/Edward

Annabelle/Edward are on their work experience at a local primary school and have found themselves in charge of the school nativity.

Move stage right Thomas, no that's stage left. Go to your right, my left. Oh my days, come here, let me show you. Andrea you need to stand in the spotlight; yes, the circle one, that's right. Okay, now after Andrea has addressed the audience, the lights come up and flood the stage. Don't cry Annie, we aren't literally flooding the stage, this isn't a scene from Noah's Ark. Listen carefully, the lights flood the stage, meaning light it all up, no arm bands required. Then Thomas, you walk towards her. Right everyone, take your positions, and action. Lights up. Lights up! And walk – stage right Thomas, we've been through this, look at where I'm pointing. Andrea, face front, no one can hear you. Project, project! Okay you two take five, we will try again shortly, but please try to follow my direction. Now at this point we all see the star in the sky shining bright, Donna can you shine bright? Arms and legs outstretched and twinkle, just give it a bit of jazz hands. Then you all slowly enter the stage and gather around the manger for a song. No Jacob, we cannot sing Uptown Funk, the obvious choice here is Away in a Manger is it not?! Now everyone, sing loud and proud; Mr Jeffries, the piano please. Ah

beautiful, now stay in time with Mr Jeffries, keep time children, keep time! Keep time with the piano, 1, 2 ,3 ,4, slow down, we are not rappers, we are choristers. Alfie maybe you shouldn't over-project, can you sing in a sort of whisper? Clearly not. Alfie just mime it, all the best singers do. Lip sync the words, remember when miming we don't hear a sound. Not all of you! The rest of you sing! Ok maybe just one verse Mr Jeffries. Thank you. Great and moving on, where's my Angel Gabriel? Ah there you are Shanice, why the sad face? What do you mean you don't want the part? It's one of the lead roles. I'm sure your dad has told you it's a part for a boy but in my version of the nativity we are not gender specific. So grab your tinsel, stick it on your head and reign down from the heavens. Oh I don't know how, just float in or something, get on your tiptoes that should do it. Now deliver your line with conviction – no Shanice, it's not the same conviction as your mother has, it means be convincing. Now say your line to Mary, tell her she's going to have a baby. Where's Mary? Chicken pox? No this can't be. I haven't any understudies. Julian, you're promoted from Donkey to Mary, swap the ears for a tea towel. I know Mary is a girl, but as I said to Shanice, gender is not relevant in my nativity. How will you get to Bethlehem? What sort of question is that? Ah yes, no Donkey. Let's skip that scene, let's just magically appear in the stable after Gabriel's revelation. If Mary can magically become pregnant without having a special cuddle, then we can

magically appear in the final location of the play. Look children, everyone knows the story, the audience can fill in the gaps for themselves. We are running out of time. How do I get myself into these things? I only came for a week's work experience. Now heads up, face front, project – except you, Alfie – everyone else sing in tune and please do not wave at your parents, it is very unprofessional. Everybody, places please and curtain going up!

ENJOY THE MOMENT
Suitability: Teen
Character: Harry/Helen

Harry/Helen has told an elaborate lie about his/her exam results which has led to a surprise party and a few awkward conversations with family members.

Congratulations to me. I enjoyed the moment, but that's all it was, a fleeting moment where, for once in my life, I felt like I'd not let anyone down. My family were falling over themselves to shake my hand, to pat me on the back and tell me how proud they were and how bright my future was going to be, and I just went along with it. Thanks Aunt Jeanie, I'm really chuffed Uncle Bob, I know, who would've ever thought it? Well truth be known, I was the only one who thought it; thought it, then created the facade. It was a little white lie; I just didn't want to feel like a disappointment to my mum. I really didn't expect the whole surprise party thing. But everyone seems so happy, it would be cruel to tell the truth now. Wouldn't it? I'll just carry on with the 'I got 3 A's and 5 B's' scenario, it's nice to see the family have something to celebrate.

Err no Aunt Jeanie, I don't think I'm the college type, I was thinking of just getting myself a little job, you know, bring some money in and stand on my own two feet. I don't really think it's throwing my future away, just maybe putting college plans on hold, you know, for the time

being. No Mum it's not what I want, I've never wanted to be a teacher or a doctor, don't you think you're getting a little carried away? They're only GCSE's. Oh dear, heart beating faster, slightly sweaty palms, lie growing, I'm shrinking and wishing this party was over, time to come clean.

If I could just have your attention for a moment – no Mum, it's not going to be a speech – but I would like to start by thanking you all for coming. Oh really, please, I don't deserve your applause; this really was a much unexpected surprise. Erm anyway I'd like to say, well I'd like to announce that, that, erm. Auntie Jeanie that's a lovely dress you're wearing. Sorry I'm a little distracted. Erm, due to the unexpected results I received today, which interestingly seem to have vanished, I have decided that I would like to, erm... Retake my exams. Yes that's right I'm going to do them all again, you know, try to get those pesky little B's up to A's.

Okay so that went well. Now to find a school who will take on a lazy, unmotivated sixteen-year-old with 5 U's and an F in woodwork.

GOING SOLO
Suitability: Teen
Character: Craig

Craig is a musician, who despite his manager's efforts wants to remain a solo artist.

Collaboration? Erm I don't think that's such a top idea, you see, I'm a solo artist. I realise I've not sold a huge amount of CDs, but hey, everyone starts somewhere, right? Wait, what? A boyband? Are you serious? So basically, you want to manufacture me!? Well that's not happening. I've signed a contract and I'm afraid you're stuck with me and my artistry for two years. What? Where does it say that? Erm well no I didn't read the small print, yes I know I probably should've done but well I thought it was just about making music, good music, my music! Not very good, what do you mean? I had a sell-out concert. Well you're wrong, I'll have you know that Malfield Village Hall is a big venue! So I've not made you any money yet, but it takes time to, you know, build a fan base. I've had fan mail you know! Listen to this… 'Dear Craig, I loved your concert, you can't go wrong with a synthesiser to cover all instruments, thanks for bringing the eighties back, Sincerely Reg.' The girls love me and the boys want to be me! What do you mean, 'really?' Well maybe not all of them yet but they will, once I get out on tour. No not with my band mates, I don't have any band mates – as I said before, I am a solo artist! Look, all I need is one strong Christmas hit

and let's face it, we'll be made for life and I'll be played repetitively every November, December and January on every music channel, on every continent! Give me some artistic licence, please! I'd rather produce a cheesy festive number than a cheesy four-piece boy band ballad! What's this? Are you kidding me? You want me to dress like that? No way, I can't pull off sequins and no I don't want to dress the same as three other people, I'm a S-O-L-O-I-S-T, a soloist! I work alone, just me, with no one around me, with no sequins in sight – just me, a one-man band!

AN UNWANTED VIEW
Suitability: Teen
Character: Greg/Grace

Greg/Grace is stuck at the top of a roller coaster. With a fear of heights, his/her panic begins to escalate.

I told you, didn't I? I said these things are dangerous! I didn't want to get on, you made me. I don't even like heights and now we are stuck up here for who knows how long. No, I don't want to look at the view; we are above the treetops. That is not a great place to be, given the circumstances. I am calm! Grateful? You think I should be grateful? For what exactly? Yes I'm well aware we could've got stuck upside down, and yes I take mild comfort in the fact that blood is not rushing to my head right now. But it still does not change the fact that I can't look down without the need to vomit and as it stands there does not seem to be a rescue operation in place. Stop telling me to be calm! I am!! Oh my word, what is that buzzing around my head? It's a wasp, I swear it is, it's a wasp. Believe me, I know what they sound like, I've been avoiding them my whole life. It's on me, it's on me! Get it off! I can't escape. Look how evil it is just glaring at me; I swear if I didn't know any better that thing is laughing, an evil villain type holler. It's just glaring at me, and I can't run. Waft it, don't whack it, I said waft it. Thank goodness it's gone, I could be allergic you know, then what? If that thing had stung me and I'd blown up like a balloon, then what would you

have done? This is all your fault. Help! Someone help! Get us down from here! I'm not panicking!!!! Okay, do you know what? Yes, I am, I'm panicking. A full-blown panic fest! Get me down! Look at what? Oh that's reassuring, a man climbing up the rail, how exactly is Spider-Guy going to save us all, just gently push the carriage down? What about the loop the loop? Wait, I can hear a siren, they're expecting injuries, fatalities; this could be our last hour. Oh it's a fire engine, not sure their ladder will be long enough. We need a crane or something, or a miracle – yes, a miracle, that would be better. No I won't stop jabbering on, it's taking my mind off of the fact that we might die, oh my goodness we might Die! Help! Heeeeelp! Hang on, did you feel that jolt? I mean literally, hang on, we are moving. Oh no we still have the loop the loop to face, I think I'd rather go with the Spider-Guy option, let's hope he's off the track now though because here we gooooooo!

I MISS YOU

Suitability: Teen

Character: Edward/Ella

Edward/Ella is at his/her mother's grave side. He/she finds comfort in talking to her.

They want me to talk about it; they want me to say how I'm feeling. What difference will it make? No one really cares how I'm feeling, they're just paid to ask. I'm not afraid to talk about it, I'm just not sure what a difference it will make. Will it stop the nightmares? Will it bring you back? No, is the short and simple answer. I wake up everyday and you are the first image in my mind; I try to picture a happy moment with you, like the time we sneaked off to the beach when he was distracted by his beer. But the images I really see are indescribable. They want to know how I feel towards him; I can't even put that into words. He doesn't exist to me. I'm glad I've got you to talk to. I like it here, it's peaceful.

You deserved so much better. They say talking will help me to deal with it, but they're strangers to me. I don't need strangers, I need you. They're putting me in a foster home, Grandma is struggling to cope. Apparently I'm a handful, and it's affecting her health. So off I go to live with strangers. Strangers everywhere pretending to care. I brought you some flowers, they're not the best. I didn't have any money, so I sneaked into old Mr Cooper's garden

and picked a couple of his roses. They're your favourite colour. I wish I could see you just one more time. I miss you Mum.

TROUBLE

Suitability: Teen

Character: Charlie

Charlie has been involved in an 'incident' at school. With the fear of getting into further trouble from his parents, he intercepts a call from the head teacher.

So there may have been a small incident at school today. It wasn't just me; it was Robbie and Carlo too. But I seemed to get the blame. I don't think Miss Ribeck likes me very much; she didn't even listen to my side of the story. Without hesitation, she reported me to Mr Donaldson, our not very forgiving headmaster. So I have rushed home to try and intercept any phone calls that we may get from the school. Let's just say, if my mum finds out – even though it wasn't just my fault – I will be grounded indefinitely and I know she will take my phone too. I just have to hope she doesn't finish work early.

The phone rings Charlie answers and pretends to be his Mum.

Ah Mr Donaldson sir, *(Aside:)* it's my headmaster. Oh I'm so sorry Mr Donaldson, I can only apologise for my son's behaviour. I'm sure he didn't mean to disrupt the class. He's harmless, really Mr Donaldson, he will be very sorry I'm sure. Charlie get here. It's Mr Donaldson, he's not too happy about your behaviour, and quite frankly neither am I. Are you sorry, son? Yes Mum, so sorry. He's sorry Mr D – I mean, Donaldson. Are you going to start behaving

Charlie? Yes Mum, I'll be as good as gold. Of course he will take his punishment Mr Donaldson. Erm what is his punishment? Litter picking? Erm, wouldn't a detention be more fitting? It's a bit chilly out there in the playground. No, erm, ok.

Back in his own voice.

I guess I'll see you tomorrow Mr D, oops!

He hangs up. As he turns around, he notices his mum stood there.

Oh hi Mum, how long have you been stood there? Ah long enough. Is now a good time to offer to do the washing up? Vacuuming maybe? Okay well let me save you the time, here's my phone and all my plans are cancelled for the foreseeable. However, I would just like to add that it was Robbie and Carlo too. No you're right, you're not their mum. I'm just going to take myself off upstairs now to think carefully about what I've done. What? Mum really? Fine I'll write a letter of apology to Miss Ribeck. Okay, okay Mr Donaldson too. But it wasn't just me.

THE LODGER
Suitability: Teen
Character: Simon/Sarah

Simon/Sarah has got a lodger staying at his/her house and is suspicious of him.

My mum's got this lodger staying; she said he helps us to pay the bills. If I'm honest, he creeps me out. He stays in his room for hours on end, but I can always hear whispering like he's talking to someone. Maybe they're planning a bank robbery or a kidnap, or maybe he's just talking to himself, which is equally worrying. That's his room there so I'll have to keep my voice down a bit, or he will hear, and he could well burst out of his room wielding a machete. I'm not exaggerating, he's weird.

She turns suddenly.

Oh hi there Mr Leviton, I was just Face Timing my friend, sorry if I disturbed you. I'll try to keep it down. Are you going out? It's pretty late. Oh okay, maybe I'll see you later. See, I told you, there's something suspicious about him. Why would he be going out this late? I bet he's meeting the other gang members to plan their perfect crime.

Maybe I should take a look in his room and find out who he really is. Of course it's a good idea; I need to know who I'm sharing my house with. Okay here I go, well it looks pretty ordinary in here so far, a bit messy but then I can't talk. Yes good idea, I'll look under the bed; there's

a suitcase and it feels heavy, let me drag it out. Maybe I should put it back, I daren't open it. What if it's a body? Maybe he's not planning a crime because he's already committed one. What was that? He must be back, maybe he's forgotten something. No time to escape, I'll just have to slide under here with the body! Oh my days, oh my days. Please don't find me and chop me into little pieces.

Whispering:

Oh gosh, I feel like I can't breathe. He's going to find me and chop me up into little pieces, then stuff me in a suitcase.

Deep breaths.

David are you still there? I think he's gone. I will do, let me just prop my iPad up – there, can you see? I'm going to open it now. I am brave, I *am* brave. It's easy for you on the other side of a screen; it's scary actually being here Dave. He could come back any second. Oh my goodness, I could be his next… I could be his next victim… okay here goes… I'll open it on three. One, two…

He/she opens the case.

Three.

He/She takes a deep breath and is shocked by what is inside.

STINKY SHOE
Suitability: Teen
Character: Jemma

Jemma's mother is 'the old woman who lives in a shoe' from the famous nursery rhyme. Jemma is trying to help look after all her siblings whilst showing documentary makers around her home.

I'd like to show you around my family home; many call it unique, but I call it cramped. Most people's houses are made of brick, stone or wood, but no not ours, we have to be a bit different. Our house is made of leather – not real leather, it's faux leather, we care about animals. It's kind of cool you want to do a documentary about us. I live here with my mum and my twenty-seven siblings. I share a room with five sisters, our bedroom is over here in the heel. I'm just relieved I didn't get the toe area. This shoe used to belong to a local giant, until he plummeted to his death from a beanstalk, and believe me his feet did not smell pleasant!

My mother is better known as the old woman who lives in a shoe, but you see she isn't as old as she looks, it's having a massive brood that's taken its toll on her, 'I've got a wrinkle for each child,' she says. I try to help with the little ones, being one of the oldest I seem to have the most responsibility. I don't mind really. Liza get off of your brother! It's always noisy in our house, never a dull moment. I don't care if he hit you first get off of him! Mum

seems permanently frazzled and she's a single parent, so it can be tough. Jack give the nice lady her microphone back – sorry about that. It's a little crowded, but we manage. Liza I will not tell you again, leave Peter alone! I try to keep my calm, but it isn't easy. We have applied for a bigger residence, we had to submit our application to Old King Cole, we haven't had a response yet, but we remain hopeful, maybe when this documentary goes out he will realise our claim is valid.

You might wonder how my mother can feed and clothe so many children – Henry, you don't need to be on camera, get out of the way and leave the cameraman alone! As I was saying, you are probably wondering how my mother can clothe and feed us all, well she likes to knit, literally everything we own is made of wool supplied by the little boy who lives down the lane. Henry *I'm* on camera not you! Move. Our food comes from Old MacDonald, who kindly donates any leftover produce from his farm. Right that is it! Henry, Peter, Liza, you are sleeping in the stinky toe end tonight and let that be a lesson to you. When did you say this would be aired?

SPARKLE

Suitability: Teen

Character: Ben

Ben was happy as a young child, but as a teen he is not finding it so easy to fit in. His grandma loves him for who he is, so why do others find it so hard to accept?

Look at my sparkly shoes, do you like them? I have glitter nail varnish, and sparkle spray for my hair. I'm now going to model my sequin dress for you, Grandma, sit there and watch as it catches the light. Do I look beautiful? Swish, swish. This is how the models walk, I'm going to be a model when I'm big Grandma, then I can wear glitter every day and sparkle like the stars. My grandma agreed she just wanted me to be me.

That was me pre-puberty, tweens they call them. All sparkle and glitter, all smiles and happiness, a love for life. But recently my life has lost its sparkle, and I haven't got much to smile about. I have this confusion deep inside, and now I'm a teenager, I try to fit in. I try to be what the other kids want me to be. My daily life is exhausting, I'm playing a character, and I perform every day to my friends and my teachers, to society. I've lived with my grandma my whole life; she is my rock, my queen. She is a total inspiration to me, she has never judged me, only accepts me for who I am. She is getting old now and her memory is fading, but she talks about how beautiful I am inside

and out, and she remembers my glitzy fashion shows that I used to put on for her. She bought me these awesome shoes for my last birthday; sadly, I only wear them around the house.

What is holding me back? Is it the people around me, society or is it just me? I have these daydreams where I parade down the school corridor head to toe in glitter and all my friends and teachers are like, "Whoa! Ben you look amazing!" They're high fiving me as I pass and asking me where I got my designer outfit. Maybe they would react like this; I'd like to think so. I might not be ready just yet but when I am, I'm going to sparkle for the world to see, and I hope my grandma is right when she says, "Ben, the world will sparkle with you."

LITTLE RED LIE
Suitability: Teen
Character: Scarlett

Scarlett has met someone online who she believes to be a teenage boy.
She has arranged to meet him, but it does not go to plan.

So what if I told a little lie? I had no intention of visiting my grandma that day, she doesn't even live anywhere near the woods. She lives in suburbia with my grumpy grandpa in a retirement home. It's just what I had to tell people – okay, yes, it was a cover-up, but it started out pretty innocent really. You see my parents are pretty strict and they didn't want me to go out or have a social life, so I had to make out that I was catching the bus to the retirement home to visit my grandma. Mother packed me up with all sorts of tasty gifts for Gran, which made a good packed lunch for me on the trek to the woods.

I had spoken to him a few times and he seemed so cool, he said he loved my style and wanted to get to know me more. He talked of a cabin in the woods and it was exciting to make plans to meet there. He said his name was Victor Wolf, he was a bit mysterious and was different from other boys, he didn't even attend a school. He said he liked to be free of any conformity, which fascinated me. I liked the sound of it, living free sounded perfect. No parents telling me what to do, no school putting pressure on me. We had met over the internet, but I felt like I knew him. No one

had ever been interested in me before, in who I was and what I had to offer.

I was walking for what seemed like forever; I was getting cold, so I pulled up my hood and drew the drawstring tight around my face. It was further than I thought, and I was beginning to wonder if I had taken a wrong turn. Maybe I'll just sit on this tree stump and have a snack. My phone pings, I'm fine Mum, why are you calling? Gran is fine too. She's not? What do you mean? My heart sinks as I realise my cover is blown. My gran has taken a nasty fall and the home has contacted my mother, it soon became apparent I wasn't there. I'm so sorry Mum, I didn't mean to lie to you, I'm meant to be meeting a friend, but I think I'm lost.

My mum came to the rescue, more than she realises. I never told her who it was I was meeting that day. I pretended it was a new girl I had befriended at school. The messages from Victor stopped pretty quickly after that and then two months later, whilst on my phone, a news report flashed up – turns out Victor Wolf wasn't a cool fifteen-year-old boy, but a forty-year-old man. The girl Victor replaced me with had not been so lucky; without a doubt a wolf in sheep's clothing.

THE BIG APPLE
Suitability: Teen
Character: Karl/Kirsty

A planned birthday celebration ends in the witnessing of the September 11 attacks on the World Trade Centre.

I woke up early on my birthday morning, excited about the plans my parents had for me that day. A breakfast at the Windows on the World restaurant, on the 107th floor of the World Trade Centre. This was to be followed by a trip to Macy's toy store. I couldn't wait.

I'm ready, let's go. As we jumped in the rental car, I could feel the excitement rushing through me. Come on then Dad, let's get going. What do you mean it won't start? Give it a few revs. We will miss our booking. I felt the excitement flood from me and be replaced by disappointment. Surely this can't be happening, it's my birthday. I really want to see the view from the tower, we will literally be amongst the clouds. How many of my friends can say they've experienced that? Come on Dad, try again. This just isn't fair. Why don't we call a taxi? They might still be able to fit us in if we are late.

My dad gave up on trying to start the car – he's no mechanic – and agreed to call a taxi, or should I say a cab, as they're known as here. It arrived within fifteen minutes and off we went, only thirty minutes late for our 8.15am booking. We could see the towers standing tall

and magnificent. Then suddenly from above there was a loud noise, it was an aeroplane flying low, very low. My dad looked concerned. The cab driver pulled the car over and we all got out. Then it happened. I can't describe how I felt in that moment, we just stood silent and helpless.

That day is etched in my mind, in everyone's minds. We all know where we were and what we were doing at 8.46am that sunny morning. I'm grateful every day that the rental car didn't start that day, but I also have a sense of guilt that fate chose to protect me. My birthdays will never be the same again; instead September 11 will be a day to remember others.

HAIR WE GO!
Suitability: Teen/Young adult
Character: Marco/Marcia

A young trainer in the beauty world gives eager trainees their first session in the art of cutting hair.

Welcome to Hair Flair, and your first lesson in the art of hairdressing. And I'm your host Marco/Marcia. Look at all your lovely little faces, hungry for follicle knowledge. Okay kids, hair we go – see what I did there? Well my first session will be tools, and what is the most important tool a hairdresser can have, other than a welcoming smile and a friendly demeanour? Yes Octavia you're right, it's our dependable and trusty pair of scissors. Snip, snap! These things can create beauty as they swing from side to side, snipping and snapping their way around the client's beautiful locks. This shiny little pair of specially-crafted hair scissors are very sharp, and if not used correctly, could cause a nasty incident or at best an embarrassing situation. If the client says they want a trim, they don't expect a crop. I remember many years ago, when I was an enthusiastic trainee with a spring in my step and a sweeping fringe to die for, I volunteered myself to be the model on a day just like today. Marco/Marcia I said to myself, put yourself out there, what can go wrong? It's only a class on trimming. So I did and that's when I discovered the crew cut. I lost my luscious sweeping fringe that day, and a little bit of dignity. But it taught me a life lesson:

don't put yourself out there if Macy Marie is holding the weapon. Scarred me for a while, that experience did. But here I am, Marco/Marcia Monroe, back in the saddle and ready for my first volunteer. Volunteer? Really? No one? Not one of you is willing to be my subject? I have awards you know. I'm the 2018 Hair Flair magazine stylist of the year, they say I'm a cut above the rest, see what I did there? Have we lost our senses of humour today, why so serious? Come on Rodger, you can go first, what's the worst that can happen? Yes well there is that, but I've had years of experience since then. That's it Rodger, sit yourself here. Okay folks, hair we go!

SOLITARY
Suitability: Teen/Young Adult
Character: Laura

Laura is chronically ill and is struggling to cope with her new limitations.

I didn't know what M.E. was or what it stood for; turns out it's a long medical word that I can't even pronounce. The long list of symptoms stared at me from the bright white NHS leaflet, and I had every single one. My heart sank as the doctor revealed there was no cure. This was how I would feel for the rest of my life. You will learn to manage it, he attempted to convince me. But I'd been dealing with these symptoms for at least six months and I already knew how debilitating the illness was. My mum held my hand and gave me the biggest hug as we left the doctors surgery; I walked slowly to the car, struggling with each step, but I knew she didn't really understand, no one did. I just wanted to go back to bed, the visit to the doctor had been exhausting to say the least. The specialist wanted me to have a walking stick to encourage me to take short walks, but at the time the idea was embarrassing to me. I was young, not a pensioner, so I refused, and continued to lay down for endless hours in my bed. It had become my quiet, safe place, but it was lonely. In time, my friends stopped calling; it made me sad but then I also understood. Maybe I'd be the same if it was the other way around. I mean it must be so frustrating to have a friend cancel

their plans with you all the time. Who wants to be friends with an invalid? How can they possibly know what it feels like not to be able to walk without getting breathless, or to sometimes not even have the energy to pick up a mug to drink from? It's incomprehensible isn't it? I read this article by a doctor recently who had been working closely with M.E. and HIV sufferers; he was asked, if he had to have one of these illnesses, which one would he choose. HIV was his answer without hesitation. I think that says it all. In the eighties everyone thought it would lead to death, but lots of research later and, to an extent, it can be controlled with meds. So I still have hope there will be a cure for M.E. Hope is all I have.

Is life fair? What does fair even mean anyway? I guess if it was, then all the good people would walk with a spring in their step, and the bad, those who hurt others and take the dark path in life, would have M.E., a punishment worse than any prison sentence. If you want to know what solitary confinement feels like, then walk just one day in my shoes – if you can find the energy.

EAT ME!
Suitability: Teen/Young Adult
Character: Mel

Mel has a complicated relationship with food. She is trying to improve her diet and is testing her willpower.

You're probably wondering why I'm sat in front of this rather delicious-looking slab of extremely chocolatey cake. Your first thought would be: maybe it's her birthday, or she's treating herself to celebrate a special occasion. Maybe she bakes cakes for a living and she's simply doing a taste test of her latest creation. Well you would be wrong; I'm sat in front of this tempting slice of gorgeousness because I'm testing myself.

She sniffs the cake.

It smells so good. Just like all the slices of cake gone before it, all the ones I couldn't resist. But today is different, a milestone. I can do this. Do you think if I just give it a little lick it still counts? Will the calories transfer into my body if I just taste it for a second on my tongue but don't swallow?

My issues started when I was young, my relationship with food has always been volatile. My gran would show her love through sugar. A bag full of it every time I visited her, which was at least once a week. Every sweet and chocolate bar you could imagine. She was like a one-woman sweet factory, and back then I didn't think twice about ploughing my way through the lot, and my mother

never stopped me. I don't think I even thought they were bad for my waistline, I'd only ever been told that they rot your teeth, so I just brushed them more times a day than was required.

So here I am, testing my own willpower. Believe me, I want to devour this bad boy, but you see the doctor has told me I need to cut back for health reasons. He said if I carry on, I'll have problems when I reach adulthood. So it's important I take it seriously this time. So I'm just going to inhale the scent a few more times, then I'm going to put it in the bin.

She inhales several times and enjoys the moment.

And so I say my final farewell to you, cake. You've been good to me, you've comforted me in my hour of need, you've kept me company in front of the TV on dark winter nights and you've given me moments of sheer bliss. But you've also given me the impossible task of squeezing into my jeans, so we must part. Although I think it would be unfair to say our goodbyes without one final moment together.

She takes a bite and with her mouth full she says....

Goodbye to my little piece of heaven, hello to carrot sticks. Wait, does carrot cake count?

WHEN THE WORLD TURNED GREY
Suitability: Teen/Young Adult
Character: Football fan.

A football fan recalls the unforgettable events that took place in Hillsborough on 15th April 1989.

We arrived early that day, spending time milling about around Sheffield, killing time. The sun was shining bright and I was excited for the match. Many of my friends thought it a bit strange that a girl could be so obsessed with football, but I'd been a massive fan for as long as I could remember. I loved to watch it as much as I loved to play it, even though P.E. lessons at my school didn't include football for girls, which always baffled me. I played in the park at the end of our street, every night after school with the local kids, making goal posts from our jackets. I enjoyed going to the games, it was a real family thing for us and on the 15th April we visited Hillsborough, which turned out to be unforgettable for all the wrong reasons.

It seemed to take so long to get through the turnstiles, people were beginning to get frustrated. We just wanted to get in, and when we did there was a buzz in the air for the big match, the FA cup semi-final. But this was short-lived, as crowds pushed forward into the already crowded pens. It wasn't long before I lost my parents in the chaos, I felt panicked. People were pushing forward but there was nowhere to go, I could feel the pressure on my body and

struggled to catch my breath. The young lad next to me was stood upright but his eyes were closed, why wasn't he moving? People were scrambling up the fence, reaching for hands outstretched from above. But I couldn't even raise my arm, the pressure was too great. The next thing I know I'm stood staring out from the side-line, like a spectator feeling dazed and confused. There were people lying on the floor with their faces covered, families searching for loved ones. Why did I feel empty and frozen to the spot? I should be helping, there must be something I could do. Why wasn't I helping anyone? Suddenly a man ran towards me, he threw himself to the floor, to the person that lay at my feet. I glanced down and my heart sank, there before me was my own limp body. Was I dead? It was difficult to process. The next thing I remember was waking up in the local infirmary with my mother staring down at me with tears in her eyes. I knew at that moment that my dad was gone, compression asphyxia was the cause. He was caught in the crush while searching for me. I was told later that the football fan, whose name I do not know, saved my life. My anonymous guardian angel. I struggle with the images of that day. But my biggest struggle is survivor's guilt; I feel guilty for not being someone else's guardian angel that day. I feel guilty that I was lucky, I feel guilty that my dad died looking for me, I feel guilty for feeling guilty. But I know deep-down, the guilt shouldn't consume me. I wasn't to blame, I was just an excited football fan on a sunny day who witnessed the world turning grey.

HAUNTING
Suitability: Teen/Young Adult
Character: Hannah

Hannah is a ghost who thinks she is watching her own funeral.

Only the good die young, isn't that what they say? Well every cloud I suppose. It's strange standing here, or should I say floating here, which might I add is not all it's cracked up to be. Yep, floating here, watching you all attend my funeral. I have to say I'm surprised, I mean a few of you I fully intended to come back and haunt, but maybe not quite so soon? Look at all those sad faces. Wait, is that Jerry Brunsworth? It is! My God *(Looking up to the heavens.)*, no offence, but what in heaven's name is he doing here? I haven't seen him for five whole years; he's not even a Facebook friend! God Jerry, sorry, but really Jerry put that hanky away you faker! Most of you I expected to see, but I'm not quite sure why cousin Michael hasn't made it, probably at one of those posh fashion shoots he does in Milan! You would think he would clear his diary for this; you only die once, at least as far as I know. Well Michael darling you are the first on my to-haunt to-do list! Hang on a minute, who asked Rosie McGib to read a tribute to me? Just because we went to nursery together and big school and got drunk a couple of times at college doesn't make us best friends. Speaking of best friends, where is Jules? She wouldn't miss this, let me see, she would surely be on the front row with my family – nope, not there – she wouldn't,

would she? How could she? She's not here! Right, now I'm offended, straight to the top of my to-haunt list!

Hello, who's that? Jules? Is that you? I can hear you. Wait a minute, you can see me? Why aren't you sat down there balling your eyes out? Oh I see, this is your funeral. But I thought you'd survived the accident? I saw you on the operating table, you came around, I saw you. You followed the light? Oh that's, erm, great I think – well for me it is – you know, someone to haunt with. But really Jules I've got to ask... Rosie McGib?

NO STARS ON THIS JACKET

Suitability: Teen/Young Adult

Character: Jenny

Jenny is a tour guide and holiday rep. She feels rather frustrated that she has not yet been awarded any stars for good work. This is largely because she isn't very good at her job.

I'd like to welcome you all to Sunfair Holidays, I am your holiday rep and tour guide Jennifer, but you can call me Jenny. So here we start our journey from the airport to your luxury four-star hotel, yes, four stars! Beautiful beaches and as much food and drink as you can consume. Now if you look out of the window to the right, you will see some lovely architecture; those buildings are some of the oldest in the country. There are some wonderful stories about those constructions, I can tell you. What was that sir? Oh, nice to meet you Mr Thompson. Erm, let me answer that question, can I tell you about the history? Erm let me consult my notes, erm well Mr Thompson it's not actually in my script... Oh look at that we've gone past. Moving on... Look at those stunning views, I bet you can't wait to get those flip flops and Speedos on, eh Mr Thompson? Anyway I digress. Over to your right is... What is that? *(Fumbling through her notes.)* Well apparently it dates back to the ancient Greeks. Mr Thompson, another question? Hmm is it an amphitheatre? Let me see *(Fumbling through notes),* still looking, can't find anything here. Ah look at that we've turned a corner, so everyone just sit back, relax and

enjoy my very prescriptive notes, which appear to have gotten a little mixed up. No straying from this script, not if I'm to achieve my stars! That's nice Mr Thompson, but if you could save your questions until the end, I have a very long speech to get through and only a short journey to complete it, and if I don't, I won't get my employee star, see? No stars on this jacket, oh no! Two years I've worked for this company, I've never had a day sick; I've dealt with the rude, the loud and the ignorant, but no stars for me! Is it my fault that holidaymakers don't want to know about buildings and the history of the island? Yes, I know you do Mr Thompson! Is it my fault they just want to get to their destination without interruption? Interruption! Oh the irony, once again I'm side-tracked! I finished the speech once, April 11th 2014 – that was a moment, I can tell you, proud of myself I was. Anyway, to the left is... Oh look at that, it's your hotel. Here we are! Happy holidays!

WHAT AM I DOING HERE?
Suitability: Teen/Young Adult
Character: Sarah

Sarah is trying to make sense of her untimely death.

What am I doing here? What is this place? Who was that? Where are you? I can hear but not see you, tell me where I am. No! That's not true, I'm going to meet my friend this afternoon and we are going to have a coffee and catch up. I set off this morning, I went to catch the bus at Grove Square, heading into town... That's... that's... that's the last thing I remember. Why did you bring me here? No! That's not true, if I was dead I'd be like... like a... well, like a spirit... wouldn't I? Sit where? You want me to sit and wait? What exactly, may I ask, am I waiting for? Because right now, what I should be waiting for is the 92 bus from Grove Square to town to meet my friend who I haven't seen for two years! No I will not calm down, or be seated in your waiting room! Now tell me right now where I am and what I'm doing here, and more importantly how I can get out? ... Okay I'm listening... I am calm! ... I am calm.

It can't be true, please tell me it's not true, tell me anything else... You've kidnapped me, you're holding me hostage, you've demanded a million-pound ransom for my release... anything... anything else... I'm not ready to die, I'm too young. Is this heaven? It's a bit dark for heaven...

Oh my days! It's hell, isn't it? It is isn't it? I only took a pair of earrings, I was going to return them, honest I was, but – well, I couldn't, could I? Once I'd taken them the deed was done. Will you stop telling me to calm down! ... Oh, so this isn't heaven or hell? Going back, yes, yes that would be great. Just rewind time or teleport me back or do whatever you omnipotent beings do. Okay I'm ready, let's go. What? You're sending me back as a what?

THE BEAUTY TREATMENT
Suitability: Teen/Young Adult
Character: Laura

Laura has treated herself to a facial at the local beauticians, she doesn't get the relaxing experience she hoped for.

So she says, "My boyfriend just doesn't get it, I mean we've been dating for eighteen months now, eighteen months! Some people have been engaged, married, pregnant and divorced in that time. I'm not asking for much, I mean it doesn't have to be a big diamond, or even real, as long as it looks real and I can tell people it is, that's fine, people can be very judgy these days you know."

I'd gone in for a facial, that's all, a relaxing facial to ease away life's stresses. I've recently had a few personal issues to deal with and I'd not slept properly for a week. It was starting to take its toll on me, so I thought I would treat myself to some 'me time', fifty-five quid it cost me and they certainly didn't tell me that some nineteen-year-old girl's life story was part of the package. I'm laid on this massage bed with the sound of the sea playing from the tiny little CD player in the corner, candles burning, aromatic smells, very calm for the first five minutes. Then it started, forty-five minutes of it, she barely took a breath. I didn't respond once, you'd think that was hint enough.

"His name is Ralph, not a common name is it? Probably because he's not – common, I mean. He's actually very

sophisticated, a bit like me. He's got his City and Guilds you know, so brains and brawn, as they say. I'm sure we will make perfectly beautiful and intelligent babies, you know, good breeding and all that. He says I need to be patient, but why? When you've found the one, you've found the one, and you know, I'm obviously the one for him. Like two peas in a pod we are, does that sound soppy Lauren?" My name's Laura. "Oh sorry Laura, my best mate's called Laura. Well she was my best mate, she's not now. It's a long story…" Oh no, not another long story, twenty more minutes… blah, blah, blah. I actually felt a sense of relief when it was over. "How was that for you?" she said, it took all my power to remain polite, well almost.

It was lovely thanks, but by the way judgy isn't a real word!

THE LOFT
Suitability: Teen/Young Adult
Character: Jez

Jez believes the zombie apocalypse has dawned and plans to take refuge in the loft.

I'm telling you it was on the news, we need to get the family together and take refuge in the loft. Yes, the loft, we need to be high up, don't we? Because of the manifestations. What do you mean what manifestations? The zombie manifestations Eddie, there's an epidemic, please keep up. Yes zombies, it's on the news. So there's no time to waste, get as many cans of food as possible, then you need to get Mum and Sarah and convince them to make their way to the loft. I'm going up there now to make it zombie-proof. Eddie it's no laughing matter, have you seen *The Walking Dead*? Yes I know its fiction Eddie, I'm not stupid, but that isn't to say it can't happen. The news said it's started down South and it's heading up North towards us. You won't be accusing me of having a vivid imagination when one of those monsters has their choppers round your neck. Quickly Eddie, we are losing time.

He gets his rucksack, climbs into the loft and unpacks his essentials, he takes out several tins of food but realises he can't open them. He waits, starts to get agitated and plays cards.

Where on earth is he? Wait, did you hear that? It was like a moaning noise. Oh my days, they've been eaten, it's too

late and now there's just me! No friends or family and no weapons unless you count this cap gun. This is worse than I thought. I'm going to have to make a run for it, but what if I'm trapped?

He picks up the gun and heads towards the hatch, he opens it slowly.

You have to be kidding me, stop laughing, what's the big joke? What's fake news?

Why would I know what date it is? Oh I see, very funny, but it's past twelve noon so guess what suckers, you're the April fools, the joke's on you. And by the way, if there ever is a zombie apocalypse, there's one thing that's essential... a tin opener!

NEW HOME
Suitability: Teen/Young Adult
Character: Neil/Nell

Neil/Nell is desperate to be rehoused by the council, he/she is discussing their supernatural reasons for wanting to move but the housing officer is reluctant to believe him/her.

Are you calling me a liar? It picked me up and levitated me above the bed. I'm telling you, this place is haunted, so I need to get out. She was killed here you know: the previous owner killed his wife, then took his own life. Only cowards do that I reckon, anyway so there's been some crazy goings-on in the last week and now they're scaring the life out of me. What do you mean I don't look scared, I can't see them right now, can I? You should've seen me last night, pale as a ghost I was. You couldn't tell the difference between the two of us! That was a little joke, you know, to lighten the mood, no? Okay look, they want me to move out and I'm telling you right now that I completely agree with these crazy-ass spectres! So you need to rehouse me. Why would I make this up? Look right here on my camera roll, did you see that light? Look again. It's not dust! It was a powerful force that lifted all nine stone of me clean off of the floor. Look again, how could I video a birds-eye view of my bedroom if this hadn't happened? A ladder? Now you're joking. Anyway as if I'd go to that much trouble, If I wanted to make a fake video I'd have used a special effects app, but I literally only had time to press record as

the shadow appeared. Yes shadow, it started with a light, then I saw a shadow, then it raised me above the bed! I had no control over my body, I literally flew like Peter flipping Pan. This has nothing to do with a vivid imagination, it has everything to do with you not wanting to rehouse me. It's easier for you to ignore me.

Wait! Did you hear that? I told you didn't I, there you have it proof, you've heard it for yourself. The radiator? No it wasn't water pipes, it was clearly footsteps. Trust me to get the logical-thinking housing officer. Ok so I challenge you to stay here by yourself tonight. Ah the old 'I can't stay over because it's inappropriate and unprofessional' excuse. I think you may be a little scared. No I don't want to contact Reverend Hardy, it's not an exorcism I need, it's one of those nice new semi-detached houses on Park Way! I'm not getting anywhere with you, am I? Fine! You can let yourself out.

OXBRIDGE MATERIAL

Suitability: Teen/Young Adult

Character: Miranda/Michael

Miranda/Michael is unhappy that she/he is not making the grades at the prestigious school her father pays for her/him to attend.

What do you mean I'm not 'Oxbridge material'? My father has spent hundreds of thousands of pounds on my education. Do they not take into account breeding anymore? Get me a super-tutor, make that several, one for every subject. My parents did not choose the most prestigious British school to send me to, only to be told I will not make the grade. I need to attend Oxford or Cambridge, I've told my friends. Do you know what that will do to my reputation? To my family's reputation? No of course you don't! Why would you? You're not in this circle, are you? I don't suppose you have any circles. I'm not being rude, it's the way it is. Are they not paying you enough here? Do they not pay salaries way above that of a state school teacher? Well I expect value for money, do you realise what my father pays per term? It's more than you earn in a lifetime. He has high expectations and I expect a high IQ to match. Do something! Or I will have to get him to pull his funding! I am calm! Do you realise we have friends in high places? I will not fit in at these average universities, do you realise the percentage of working-class people that now attend these establishments, the world's gone mad. Snobbery? I really don't think you're in a

position to judge me, my father's very generous donations keep you in a job. Money talks and I expect you to give me what he pays for. So I will be expecting a glowing reference and if you need to tweak my grades, then tweak them. I won't tell you again, I must be Oxbridge material, and you will make sure of that. Won't you?

AND THE WINNER IS...

Suitability: Late Teen/Young Adult
Character: Victoria

Victoria thinks she has won the lottery and is planning her ideal wedding.

The lottery results can be heard in the background.

Yes! Yes! No way, Andy we've won a tenner! Oh my god! Wait 12, 24, 38. *(Pause as she tries to catch her breath.)* Andy, Andy get here!

This cannot be real! Where's the remote? Oh my god, I need to check again. Rewind, rewind, stop and play. 1, 4, 11, 12, 24, 38. Breathe woman, pull yourself together. Andy! I've imagined this moment a million times, million, oh my god million, I'm a millionaire! Andy! I've imagined this moment, haven't we all, but I never really expected to experience it, and I can tell you it feels good, strange but good. No more debts, no more arguments over money. We can finally afford the wedding. Andy! Come down here, I'm going to marry you! Not like last time in that dull little registry office. We can renew our vows properly, it will be the wedding I always dreamed of. I'm going to turn up in a horse and cart, no wait, a crystal-encrusted carriage. It will be like Cinderella going to the ball. That's exactly what it's like, I'm Cinderella and my Fairy Godmother is sending me to the ball. It's going to be the best party you've ever seen, Andy! Where the hell is

he? Andy get down here, I have the best news, you won't believe it. I will have the most beautiful gown, like those you see in the magazines. All covered in diamantes, no wait I can afford real diamonds, oh my days I can afford real diamonds! Andy get down here! We can afford real diamonds! I will sparkle from head to toe, I'll even dazzle the guests and don't get me started on the tiara, I mean crown. Andy! Oh there you are, about time. Didn't you hear me shouting? Where've you been hiding? Sit down, you'll need to sit down. What's the matter? Why are you looking so sheepish, come here, I'm about to make your day! What do I need to sit down for? It's you that needs to sit down. Okay, okay I'll sit down. *(Pause.)* You did what!?!? Fake? The ticket's a fake? Why? What? I mean WHAT? *(Pause.)* Funny! You thought that was a good joke, I'll give you joke! This situation begs one question, how will I pay for the divorce?!

THE URGE
Suitability: Late Teen/Young Adult
Character: Jason

Jason is meeting with his psychologist, he is talking about the urges he has to kill.

It's an urge, an uncontrollable urge, something deep inside. I just want to know what it feels like. I was thinking smothering with a pillow would be interesting, but it would involve a lot of physical effort on my part. So maybe a bag on the head would be more stimulating to watch, you know? Just sit back and watch it happen, slowly. I'm not sure what's made me this way. It's always been a fascination of mine, even when I was at school I would daydream about it. Other kids had hobbies like football and music, they would hang out and find mundane things to laugh about. I didn't understand them or their humour. I didn't need friends anyway. My past-time was reading, I read factual books about infamous people and how they made their mark. It's not infamy that drives me, I'm just curious. They say curiosity killed the cat, well there's a certain irony about that, as that's how it all started for me. You see, I've tried suffocation before, on my neighbour's cat, but I got bored so just reached for the kitchen knife, not very creative I know but it did the job. I read in one of my criminal biographies that apparently that's how many psychopaths start, but you see I'm not a psychopath, Doctor Bailey. I'm not sure why I'm even here. I haven't

followed through with my fantasies, well not since the cat episode. Wanting to know what something feels like does not mean it will happen. You really think I'm a danger to society? Are you scared of me Doctor Bailey? Why not? What if I decided you will be my first victim, human victim I should say? Do you think you could stop me? Will your PhD save you? Maybe you can intellectualise your way out of this situation. I'd watch your back, Doctor Bailey, if I was you; I don't like interfering people who think they can save me. You need to save yourself first. Where do you think you're going Doctor Bailey? I think you'd better sit down!

EVIL PERSONIFIED
Suitability: Late Teen/Young Adult
Character: Nicky

Nicky talks of the responsibility he/she feels after letting his/her sister play out the day she was murdered.

It took all my strength to get here today, to sit in this courtroom and face the man I despise. The only way I can describe him is evil personified. What he did to my sister is inexcusable, despicable. It makes me re-evaluate the country's decision to abolish capital punishment, I mean my sister can no longer walk this earth so why should he? My little sister was... using the past tense is so hard... my sister was so beautiful inside and out, so innocent. He robbed her of that innocence, he robbed her of a future. She always had a smile on her face, the happiest little girl. If only that day I had not let her play outside on her bike, Mum had left me in charge and I let everyone down. I let Esme nag me: 'Please,' she said, 'all my friends are allowed out. I won't tell Mum if you don't,' so I let her, and that decision will haunt me forever. I remember so vividly her little pink bike in the ditch looking alone, a symbol of what was to haunt me forever. So here I sit next to my mother, who hasn't been herself since that fateful day. I sit here feeling a sense of guilt and anger burning through my veins as I stare at the man who stole my sister's life. He shows no remorse. How can you sit there and feel nothing? You monster! We await the verdict, but I know

that no punishment will be strong enough, no amount of justice will bring Esme back, and no matter the outcome, my family will remain in pieces, broken. I lost my mum that day too and I want her back, I want us all back the way we were before the devil entered our lives.

REST IN PURGATORY
Suitability: Late Teen/Young Adult
Character: Lisa

Lisa read an article in the paper which makes her thinks back to the day she escaped a dangerous man.

I can hardly believe what I'm reading, my mind flashes back to 1979, a young girl on a hot summer's day playing out with all the other local kids on the street, without a care in the world. We would play all day, only going home to be fed and watered. That's how it was in the Seventies, and it was a great way to grow up, to feel free to live fearlessly. Anyway, this one summer, some builders had moved into our street to expand it with further housing. For us lot it meant exciting new places to play, foundations made great mazes, there were numerous hiding places and a big mound of earth that was great to slide down. The builders and our parents didn't seem to be bothered by our new playground. It felt good to be having a new adventure. Graham was one of the builders, looking back I suspect he was the boss. He asked us one day if we would like to take turns going for a ride in his digger. He didn't need to ask twice, we were all yelling 'me first, me first!' I didn't go first, or second, in the end I didn't get a turn at all. Mum called me in, 'We are going to visit your Grandma,' she said. 'Get cleaned up.' And that's what I did. The next day, my friends were pretty quiet about the digger rides, I thought it strange they weren't more excited. I figured

they didn't want to make me feel jealous and nothing more was ever said. For some reason, everyone was bored of the building site and didn't want to play there anymore. Luckily the farm had a new set of bails and that was always a favourite playground when you were a country kid. To me, that summer was pretty ordinary, but looking at this paper I'm guessing it changed some of my friend's lives forever. I feel angry and relieved as well as guilty that it wasn't me. I'm glad one of my friends from summer 1979 has found her voice and that Graham has been exposed; it's a shame his death four years ago means he will never feel the hand of justice. RIP Graham, Rest in Purgatory.

SOMETIMES

Suitability: Young Adult

Character: Margaret

Margaret has made a tape for her husband as she is aware that she has early signs of dementia.

Sometimes. That's what they said. Sometimes. That is what I have left to pin my future on. Sometimes. Sometimes I will know your name, sometimes I will remember the fun times we had, sometimes I will know you are my husband, my son, my friend. Sometimes, but not always, never always. Always isn't even part of my vocabulary, I won't even always know what always means. If this sounds confusing, it's nothing compared to what is ahead; there is one guarantee and that is that for me, always will be never. I can only rely on sometimes, and then, as the years pass, sometimes will become infrequent and I will be left to rely on occasionally. Occasionally you will walk into the room and I will know your name, but I may not know why or how I know you. I don't want you to have to go through this; you will be left with frustration, at first occasionally, but eventually, always. If you are watching this tape you have got to this point and I am already lost. I want you to know that you mustn't feel the need to take care of me, I am not the girl you married, I am a woman lost – not sometimes, or occasionally, but always. Live what is left of your life with the memories that you are lucky enough

to retain in your mind, hold them close to your heart and know that I love you always.

STOOD HERE LOOKING AT YOU
Suitability: Young Adult
Character: David

David is addressing Julie, who he has had an affair with; he is re-evaluating his relationship and the effects on his son.

So here I am, stood here looking at you, wondering if we're doing the right thing. It's not that I don't want to, I do, but it's caused enough tension already. I can't just ignore all the things that have gone before, all the hurt it's caused – we've caused. Don't look at me like that, it's not that I'm breaking up with you, I just think we need to slow down. My divorce hasn't even come through yet and my son hasn't come to terms with everything, he's not ready for a new mother figure in his life. He said to me yesterday, 'Dad I think you and Mum will make up and we will be a family again, stop being mean and come home.' Yes, I know he doesn't fully understand but kids see what's happening, he can see how sad his mum is and he knows that's because of me. That's unfair Julie, I care about you too, you know I do, but he's my son and it's only been a few months. Ok so it's been a few years for us, but to everyone else I've only known you a couple of months. Look we could talk about this all day, but the fact is the timing is all wrong and I need some space to find me again, I know it sounds selfish but I've put everyone through enough and my head is spinning, two years of

lies and sneaking about is exhausting. So I'm stood here looking at you, wondering if I could have the ring back.

THE ROBBERY
Suitability: Young Adult
Character: Andrew

Andrew is mourning the loss of his wife after she is shot during an armed robbery.

Just do what he says, get up slowly and don't make any noise. I'm right here honey, just nice and slow.

He kneels with hands above his head.

Try to maintain eye contact. I know you're scared but it's going to be fine, just do what he says. Just give him the ring honey, it doesn't matter what it means to you, he doesn't care, just give it to him. My heart was thumping hard in my chest and as brave as I was trying to be, the truth is I was truly terrified, more for my beautiful wife than myself. I wanted to be the big man, the protector who would save the day, but I was too scared to move. Give it to him, just give him the ring – but she didn't, and I find myself here, knelt once again, but this time by her graveside. It was just a ring, it was nothing in comparison to a life. But she saw it as part of her; in her mind, to hand it to him would've been a betrayal of our love, she was stronger-minded than I ever was. The evil that broke into our house that day and shot my wife in our own home fled, he fled without being caught, he fled and left behind devastation. He fled empty-handed, leaving me empty inside. It seemed to take forever for the ambulance to arrive, time seemed to slow,

in truth it was a matter of minutes. There was nothing they could do to save her, she left me that day alone and in a world that suddenly felt surreal. So many emotions consumed me in the days to follow. Why couldn't she have just given him the ring? Anger filled every vein, but it soon turned to guilt, why wasn't it me? Why didn't he take my life? Why couldn't I protect her? Why didn't you just give him the ring? Do you know the funny thing is, it's not even real diamonds! Sure I pretended it was real, I didn't want to disappoint you, but I think you knew. I miss you, and I'm sorry I couldn't protect you.

DESPERATE

Suitability: Young Adult

Character: Alan/Alice

Alan/Alice is desperate for money to help with the hospital fees for his/her daughter, he/she holds up a young woman and attempts to rob her.

If you just sit still, no one will hurt you. Shut up, just shut up! I said shut your mouth. No one will hear you, there's no one here. Now tell me where the safe is. I'm not mucking around here, I'll use this, I'll pull the trigger and no one will find you. No one cares; if they did, they'd have helped you by now. Don't get clever, I know what I said. Even if they did know you were here, they wouldn't help you. You're just a rich toff, no one likes people like you, no real person anyway. You live in your plastic world without a care for anyone, you don't give a second thought for people like me. You think I like having to do this? You think I've done this before? Well you're wrong, I've never done this before, I've never needed to. Do you hear that, toff? 'Need to', I need to do this, it's not that I want to. You see, I may seem a little over-emotional here and you may wonder why, but more than likely, you don't care. You just want to get out of here without a bullet in your brain. I don't blame you, if I was sat in your situation, I'd be the same – no wait, I wouldn't, because I have feelings! I'd want to help people like me, yes that's right I'd want to help me. Now stop wasting my time and tell me where the

safe is! This is a matter of life and death, and not just for you. Oh now you speak! Why? You want to know why? I'll tell you toff, I'll tell you exactly why. You see this, that's a picture of my daughter, beautiful right? Well I need to see that smile again; I need money, so you're going to help me. For God's sake, the safe, where the hell is it? Look at me, LOOK AT ME! Stop crying, jeez, it's not like you're skint. What do you need all that money for? Botox? The latest gadgets? Therapy? Right that's it, you've had enough opportunity, sod you, sod you, *(getting increasingly emotional)* I just wanted to save her, I just wanted to see her smile. It's not even loaded, sod you.

FASHION BUZZ
Suitability: Young adult
Character: Lizzie

Lizzie is a shopaholic who finds herself in therapy for her ongoing spending issues.

No one tells you when you're at school about money matters. No one tells you that this shopping card and that credit card will bring you such misery. When I was a young girl, I longed to look like all the beautiful girls in the magazines, I would cut out all my favourite clothes from the catalogues and stick them in a scrap book. Later, when I eventually had my own phone, I downloaded all my favourite clothes shop apps and racked up thousands of pounds worth of fashionable goods in my wish list, but that's just what it was, a wish list. So as soon as I was old enough, I took out my first shopping card, it was like heaven. I felt like a celebrity choosing any outfit I wanted, it made me feel great. I got a buzz every time I went shopping, or every time the doorbell rang and the delivery person handed over a parcel with my name on it. What was I thinking? Did I really think it was a magic money card? Did I really believe these things were free? I felt great, I looked fabulous and I was having fun.

But now here I am sat talking to you, wondering how therapy is going to clear my debt. I know you call it an addiction, but do you know what? I don't think that's what

it is. I just want to feel special, and that's what shopping does, at least in that moment. Then I feel miserable when the letters come through the door, the threats, the final demands. I can't see a way out. I did what you asked, I chopped up every piece of plastic in my purse. But I still don't see a way forward. I could sell everything I've bought on eBay, but it still wouldn't clear my debt. If only someone could've taught me about money matters, it would've served me better than Geography or French ever did. Hindsight's a beautiful thing, more beautiful than any handbag or designer dress. But hindsight can't rescue me, and when I feel helpless and depressed about my situation, guess what makes me feel better? Yes, shopping.

ME TOO!
Character: Young Adult
Character: Actress

An actress shares her story with young girls wanting a career in the entertainment industry.

I wanted to be an actress and I spent hours and hours working on show reels, headshots and CVs. I was so hungry for the industry. I knew I had talent, I knew which jobs suited me and which didn't. I trained at stage school and I worked hard, managed to bag myself an agent soon after graduating and had high hopes for a glittering career. I'd heard about the casting couch, I was aware of what it was and I knew people who had experienced it, and sadly gained work from it. It wasn't long after I started on the audition trail that I came face to face with this very dilemma. I'm a clever, intelligent woman and not easily manipulated, but my dreams were big, and he knew that.

My name was called and I entered the room. It was more lavish than anywhere I'd auditioned before and I perched on the edge of the chaise lounge, feeling more nervous than usual. The job was for television and I'd only ever auditioned for theatre, so it was different from what I was used to. He quickly made a complimentary comment about my headshot, from the outset he seemed more interested in my physical appearance than any talent I had to offer. He positioned himself next to me, too close

to me. I quickly became anxious. He asked me how much I wanted to work on TV and what I was willing to do to fulfil my dream. He touched my hand, my heart sank and I felt shaky, I slowly pulled away. Part of me didn't want to offend him, that seems ludicrous to me now, but at the time I wanted to be polite. He reached for my leg, I pulled away without hesitation this time. He didn't seem to feel any shame and when I pulled away there was no fear in his eyes that he'd crossed a line, no remorse. He still felt powerful. Invincibility is something only superheroes experience, is that what he thought he was? There was nothing heroic or super about him, he was a man with money, and he clearly considered his superpower something that could make young girls like myself weak and desperate. I quickly made an excuse and began to leave the room. He told me I would never work again. I left the building as fast as I could. And I didn't tell anyone, I felt shame that I'd been made to feel so vulnerable. I kept my secret for over a year and decided to abandon my dreams and everything I'd trained hard for. I didn't want a part of that world. Not now, not ever. But I am here talking to you today to finally share my story, a story we now know is not uncommon. Don't hide the truth, not now you know that it happened to me too.

I DO

Suitability: Young Adult

Character: Vicky

Vicky discovers her husband plans to marry again and decides to confront him and his unknowing bride at the church, about his double life.

I object! You can't marry him. He's already married; he has been living a double life. Yes Adam, I found out your little secret, you can't even look either of us in the eye. Why won't you face me you coward? You thought you had it all worked out, didn't you? Go to see her for your tea straight after work, then come home to me to eat the tea I cooked for you. No wonder you've piled on the pounds. All this working away crap, was just that, and that great job you claim to have, all that is a lie too. I found your secret phone scumbag; it wasn't difficult to figure out your pass code, do you know one of the most popular passwords used across the country is a football team. You couldn't even do that well. Sorry Father, you look a bit gobsmacked, I bet no one has ever stopped one of your weddings before, but this poor excuse for a man has let everyone down. Me, his family, his friends and his new bride-that's-never-going-to-be. No offence love, but you're better off without him.

Look at you all sat here, dressed up, bet you've spent a fortune on those outfits and wedding gifts. Let's hope you've all kept the receipts, because this man you thought

you knew is a stranger to us all. Or some of us – I bet those pathetic mates of yours are in on it all. Even your mum hasn't turned up today! Don't blame her, did she find out? Was she ashamed of you Adam?

Turn around and look me in the eye, Adam Stevenson. I said look at me! Oh erm... you're... not... Adam, oops sorry wrong church! I'm so... erm sorry, and this bride of yours is beautiful and I bet you're going to have the most beautiful family and live happily ever after. Vicar, continue! I'm just going to step outside. Happy wedding day to you both. Proceed. Awkward.

WHAT I NEVER HAD
Suitability: Young Adult
Character: Annie

Annie is struggling to think positively about her future after an accident leaves her paralyzed.

Watching the clouds pass by, listening to the same tune over and over again. Thinking back on my life, on the good, the bad and the indifferent. Changes never come easy; I need inner strength as, physically, my body fails me; I need to find strength of mind. But right now, the tears are trickling, and I can't even say they're tears of sadness, just emptiness really. What is true love anyway? You can't miss what you never had.

Since the accident I find it hard to leave the house, Julia my carer is the only person I see regularly. She visits every day and puts up with my varying moods; she has the patience of a saint. My family live too far away to visit regularly so I'm pretty much alone.

When I was a child, I would read stories about the prince whisking the princess away. I would dream of my future. I've never been ambitious, so it only involved a nice house and a husband, a family of my own. But I can honestly say I have never even had a proper boyfriend, and now I find it difficult to see how I could ever meet anyone, or how anyone would want to meet me. Julia has tried to set me up on dates, but I've never seen it through. It makes

me anxious and I feel desperate having my carer plan my love life.

It was a sunny morning the day it happened, but that's pretty much all I remember. I always rode my bike to college, I'd never learnt to drive and I couldn't afford lessons. Besides I was helping the environment, wasn't I? Like I say I don't remember the incident, I just woke up in hospital, but I've been told a car took a left turn and didn't see me riding on the inside down the cycle lane. When I came round, I knew from the nurse's face that it wasn't good news. I couldn't feel my legs.

I like to get out of my chair, with Julia's help of course; lie on the grass and breathe that fresh air. Dreaming, hoping one day my prince will come. But I know that what I need to do is get out there and find him myself, that time will come when I'm ready – but as I've said before, you can't miss what you never had.

The following two monologues inspired the play *Who Needs Enemies*.

Suitability: Young Adult

Dee has killed someone in a hit and run, she had been drinking and fled the scene. She goes straight to her best friend's house and begs her to help. It is revealed that Dee has put the body in the boot of the car; Claire is persuaded to help bury the victim. But not all is as it seems, and the final scene of the play reveals a dramatic twist.

CLARE'S MONOLOGUE

Can life get any better? I did the test this morning, I can't believe it, Steve won't believe it either – after all this time, finally it's positive. I did another five tests to be sure! I wanted to tell him straight away, but decided I'm going to wait and tell him tomorrow, he's got a night off and I'm going to make it really romantic, a night we won't forg-

It was at this point that fateful night when there was a knock at the door, I glanced at the clock, five past midnight, who could it be at this time? Steve isn't due back from his night shift until the morning.

Suddenly the knock became a heavy rap. It made me jump. I say 'rap' because it was so much more than a knock, it sounded desperate, or extremely angry! I felt alarmed for a second; I paused and considered ignoring it. The door was locked, the bedroom light was dim, maybe they'd think I was out and go away. I picked up my pen to

continue with my diary entry. Suddenly the doorbell rang and the rapping got louder. I threw my pen on the bed, it lay there next to my diary, and I approached the door, a door I would go on to wish I had never answered.

Suddenly the letterbox opened and a panicked voice yelled my name: "Clare let me in, I know you're there." Jesus what was she doing scaring me like this? I recognised the voice straight away.

Dee was my closest friend, and had been since we started school, and all these years on we were as close as ever. There is nothing I wouldn't do for her… but as I opened the door and saw her hands covered in blood, I knew our friendship was about to be put to the test.

DEE'S MONOLOGUE.

What have I done? I kept driving, I didn't look back, I couldn't look back… I wouldn't. Maybe it didn't happen; this must be a dream, a really bad dream. It wasn't my fault. Clare will know what to do, she always has the answer, I can't do this on my own. What if I go to prison? I'm not the sort of person who goes to prison, they would realise that. Things like this don't happen to me, but it did just happen to me, it wasn't my fault. My heart feels like it's going to explode if it doesn't slow down, maybe I'll have a heart attack and die. People would say I deserved it, do I deserve it? It wasn't my fault. It was his.

I pulled into her road, the bumper still scraping the tarmac. I didn't care, I just couldn't go home, I couldn't face this alone, why should I? It wasn't my fault. I needed Clare, she wouldn't blame me, she would understand that it wasn't my fault.

I ran out of the car at such a pace I took a tumble, I put my hands down to brace my fall, Jesus is that blood on my hands? I looked down, there was blood smeared down my top, reality hit me, this was no bad dream. I had to face what I had done or convince Clare to cover for me. She always had been the strong one; I was always a little jealous of her popularity, but she protected me, she always stuck up for me, she would surely do the same now.

I banged on the door; I was shaking, come on Clare, answer the door. I looked over my shoulder feeling nervous, panicky, paranoid. Why is the street so quiet, it was so dark… late. Why aren't you answering the door, answer the flaming door! I rang the bell, banged as hard as I could on the glass door and shouted through the letter box. I know you're there; Clare let me in, open the door. Clare open the damn door! It felt like forever. I wiped my bloody hands on my jeans as the door opened.

Other Books Available by Joanne Watkinson

A Striking Friendship

"This well written play is an excellent reminder, not only of the
financial hardships experienced by families during the miner's strike,
but also the unbearable strain put upon friendships. A great read and
an ideal play for a variety of groups to perform." Amazon Customer

Who Needs Enemies

"This is my favourite play from this playwright. With a great twist at
the end." Rosie Buckley (LAMDA Tutor)

The Drama Pot Books

"A wonderfully diverse collection of monologues.
Such rich, interesting and inventive scenarios for young students to
explore. I would certainly recommend this book to any drama or
LAMDA teacher." Luke Stevenson (Drama Teacher)

"I've used The Drama Pot for my last few drama exams. The children
really enjoy the monologues and we have received great results.
Highly recommended." Jacky Rom (Author & Drama Teacher)

This author has recently released two plays for young people.

Intrusion

Intrusion is an ensemble play which explores the world of protagonist Susan Jameson, a young girl who suffers from Intrusive Thoughts which have plagued her life. The play explores mental health issues related to this, including anxiety and OCD, and tracks her progress from child to young adult.

The play is written with flexible casting in mind. The size of the cast and gender balance is left to the director. The play works best in a stylised format, with music and movement playing a significant role.

Fleeced

There has been some unusual activity in Nursery Rhyme Land and Bo Peep has lost her beloved sheep Baabra and Baartie under suspicious circumstances. The Duke of York is brought in to lead the case and the play takes us on a 'Who done it?' style journey which culminates in a surprising outcome. There are a number of suspects including traditional nursery rhyme favourites like Humpty Dumpty, Wee Willie Winkie and the Queen of Hearts. It is action packed, funny and heart-warming.

The play is full of vibrant characters which children will be familiar with and will love to play. It has a large cast but could also be performed with a small group of actors using multi role play. Aimed at 7-13 year olds, but could equally be successfully staged by older children and adults for a young audience.

Coming soon...
It Started With a Kidnap

Printed in the USA
CPSIA information can be obtained
at www.ICGtesting.com
JSHW021106290824
69014JS00004B/100

9 781913 630645